IF AR
25X3

B Hopek
9/94

VERNACULAR VISIONS:
FOLK ART OF OLD NEWBURY

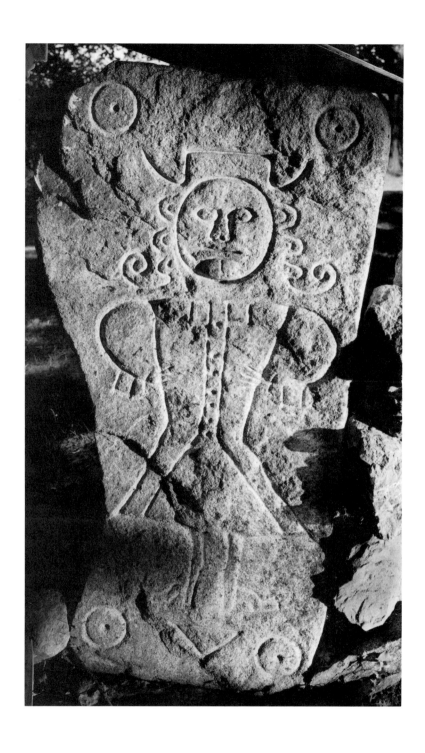

1 *Frontispiece*
Carved diorite boundary marker, "Witchstone Farm,"
Newbury, ca. 1660

VERNACULAR VISIONS:
FOLK ART OF OLD NEWBURY

Catalogue of a Partial Loan Exhibition
Cushing House Museum
Newburyport, Massachusetts
May 7 – October 31, 1994

JOHN HARDY WRIGHT

First Edition: Copyright © 1994 by John Hardy Wright
and the Historical Society of Old Newbury

Published by the Historical Society of Old Newbury
Cushing House Museum
98 High Street
Newburyport, Massachusetts 01950

Designed by John Hardy Wright
Edited by Bettina A. Norton and Susan Sexton
Typeset in New Century Schoolbook
Printing and binding by the Newburyport Press, Inc.

Library of Congress Cataloging-in-Publication Data
Wright, John Hardy –
 Vernacular Visions: Folk Art of Old Newbury
 Includes bibliographical references and index.
 1. Newbury (Mass.)—Folk Art. 2. Folk Art—Newbury (Mass.)—Folk Art.
Pictorial works. I. Title.

 ISBN 1-882266-03-X 94-76326
 CIP

Printed in the United States of America

Front cover: Oil portrait on canvas of James Prince (1755–1830) and his youngest son, William Henry Prince (1792–1854), by John Brewster, Jr. (1766–1854), painted in Newburyport, 1801 (entry 38).

Back cover: Pieced, appliquéd, and embroidered quilt, probably made by Phoebe Harrod (1786–1887) in Newburyport, ca. 1825–1845 (entry 58).

Title page: Architectural rosette, from the "Old South" meeting house, ca. 1756 (entry 80).

Contents

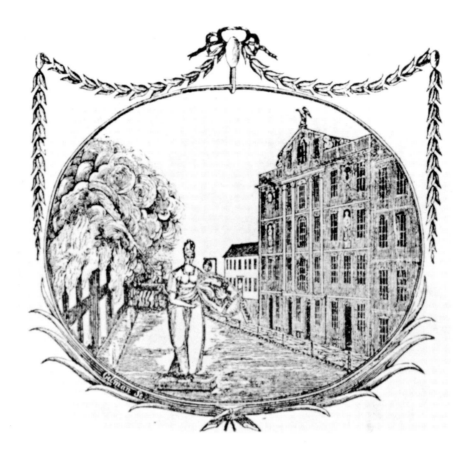

2 *State Street, Newburyport*
J. W. Gilman (1741–1823), Newburyport, ca. 1811
Wood engraving, 4 x 4 1/8 inches
The Architectural Heritage of the Merrimack, Fig. 168

The local woodcarver and sculptor Joseph Wilson (1779–1857) probably made the eagle, corner brackets, bas-relief plaques, and full-scale figures in niches that adorned the imposing Phoenix Insurance building. The neoclassical style structure was destroyed in the Great Fire of 1811, three years after it was built. Located adjacent was the eighteenth century Wolfe Tavern, the large hanging sign of which is in the collection of the Historical Society of Old Newbury.

Reference:
John Mead Howells, *The Architectural Heritage of the Merrimack* (New York, N.Y.: Architectural Book Publishing Company, Inc.), 1941, p. 137.

> *Some of the objects illustrated in the catalogue could not be included*
> *in the exhibition. Those in the collection of the Historical Society of*
> *Old Newbury (HSON) are not identified as such; others are noted as to*
> *ownership in public or private collections. Catalogue entries in the*
> *text and in other entries are indicated by a corresponding number*
> *in parentheses. Height precedes width.*

Preface and Acknowledgments

The year 1994 may well be remembered as one of celebration of folk art in the eastern part of the United States. Exhibitions in Bath at the Maine Maritime Museum *(Nautical Folk Art)*; in Concord at the New Hampshire Historical Society *(Valuable and Curious Arts: The Folk and Popular Tradition in New Hampshire)*; in Marblehead, Massachusetts, at the Marblehead Historical Society *(Marblehead Folk Art)*; in Salem, Massachusetts, at the Peabody Essex Museum *(In the American Spirit: Folk Art from the Collection)*; and in Newburyport at the Historical Society of Old Newbury *(Vernacular Visions: Folk Art of Old Newbury)* feature important decorative and cultural artifacts of their respective institutions.

In late January, the first part of the well-documented American folk art collection of Bertram K. and Nina Fletcher Little, who resided summers in nearby Essex, Massachusetts, was successfully auctioned at Sotheby's in New York City; the second part is scheduled for auction in October as the exhibition in Newburyport closes. The Littles' summer residence, Cogswell's Grant, will open this season much to the delight of folk art mavens who have read about their significant personal collection.

In mid-December of 1993 the idea of having a folk art exhibit at the Historical Society of Old Newbury (hereinafter referred to as HSON) was born. Within a few months' time, concerned and well-connected individuals, museums, and historical societies responded favorably to the idea and the accompanying catalogue. Without their invaluable encouragement and assistance this exhibition and catalogue could not have materialized. It is to their tireless efforts that the author will always be grateful.

INDIVIDUALS: Mae Atkinson; William Bairstow; Arthur Bartlett; Mimi Batchelder; Herbert E. Bean; John Beckwith; Derry Bray; Edward L. Brown; Paulina Condon; Carl L. Crossman; Joan K. Davidson; Paul DeCoste; Dean A. Fales, Jr.; Tracey Aldighieri Fortier; Kenneth and Corrine Glazebrook; Daniel and Janet Graf; Carroll, Claudia and Perry Hopf; Elizabeth S. Hunt; Helen Kellogg; Dr. Arthur B. Kern; Elizabeth Knight; Glee F. Krueger; Elizabeth G. Lahikainen; Lilith Lemieux; Virginia Leonard; Selina Little; Ann Eldredge Little; Sylvia B. and Wilhelmina V. Lunt; Kenneth Martin; F. Forrest Morrill; Martha Perkins; Betty Ring; Robert Rogers; D'Arcy G. van Bokkelen; Nancy V. Weare; Bertram Wolfson; Bertha S. Woodman, and Barbara Wright.

INDIVIDUALS ASSOCIATED WITH BUSINESSES AND INSTITUTIONS:
Bruce M. Bear, Jr., Thomas Pulkkinen, Newburyport Masonic Temple Association;
Cynthia W. Brown, David H. Brown, Jr., Paul Lenz, Christine Moore, Beth M. Weeks,
Newburyport Press, Inc.; Helen Burns, Framing By Design, Danvers, Massachusetts;
Lucy Butler, Daniel Finamore, Kathy Flynn, Nancy Heywood, Dean T. Lahikainen,
Mark Sexton, Jane Winchell, A. Paul Winfisky, Peabody Essex Museum, Salem,
Massachusetts; Nancy Carlisle, Nina N. Maurer, Richard Nylander, Ursula Wright,
Society for the Preservation of New England Antiquities, Boston, Massachusetts;
David Casey, The International Antique Mart, Byfield, Massachusetts; The Reverend
Roger W. Cramer, St. Paul's Church, Newburyport; Jonathan Fairbanks, Museum
of Fine Arts, Boston, Massachusetts; Stephen L. Fletcher, Karen M. Keane, Ann
Petrone, SKINNER, Inc., Bolton, Massachusetts; Serena Furman, John D. Hamilton,
Museum of Our National Heritage, Lexington, Massachusetts; Katherine M. Gove,
West Newbury Historical Society; William Guthman, Guthman Americana, Westport,
Connecticut; Kellen Haak, Kathleen O'Malley, Hood Museum of Art, Dartmouth
College, Hanover, New Hampshire; David Hall, Bulfinch Auction Gallery, Boston,
Massachusetts; Stacy Hollander, Museum of American Folk Art, New York City;
Brock W. Jobe, Winterthur Museum, Winterthur, Delaware; Celeste Johnson,
Gary Kincaid, Custom House Maritime Museum, Newburyport; Dorothy LaFrance,
Newburyport Public Library; John Larkin, Jr., Old Sturbridge Village,
Sturbridge, Massachusetts; Barbara R. Luck, The Abby Aldrich Rockefeller
Folk Art Center, Colonial Williamsburg, Williamsburg, Virginia; Jennifer Oka,
National Museum of American History, Smithsonian Institution, Washington,
D.C.; Diane M. Ostering, Kaplan, Choate & Co., New York City; and Ingrid M.
Sanborn & Daughter (Greta Shepard), West Newbury.

Meritorious assistance was provided by Peter Benes; Gregory H. Laing;
Wilhelmina V. Lunt; and Christopher L. Snow. Invaluable Museum Collections
Management Committee members include Peter Eaton; Sandra Le Pore; Scott
Nason; and Messrs. Laing and Snow. The top-notch fabrication in the society's
Dr. Francis S. Benjamin, Jr., lecture hall was done by Campbell Seamans and
John Seamans.

Funding for the exhibition and catalogue was made possible by support from
the T. Raymond and James K. Healy Fund for the preservation of maritime artifacts,
and by Wanda W. Blanchard; Gregory H. Laing; Lilith Lemieux; Sylvia B. and
Wilhelmina V. Lunt; Frederic A. and Jean S. Sharf; and Christoper L. Snow.

Introduction and Dedication

In the early 1920s a nascent group of contemporary New York City artists and gallery owners began collecting American folk art of the eighteenth and nineteenth centuries.[1] These avant-garde individuals summered and painted in Ogunquit, Maine, where through the exchange of ideas, they became fascinated by the simple, colorful, somewhat abstract paintings and sculpture of the past, elements of which they incorporated into their own "modern" artwork.

Local collectors of Americana include Ben: Perley Poore (1820–1887), government employee and historian, and the Rev. Glen Tilley Morse (1870–1950) of All Saints' Church. These West Newbury residents inherited many artifacts from their families and augmented their own collections with interesting and unusual objects acquired through their lifetimes.

The term "folk art" was defined in a 1930 painting exhibition pamphlet by three little-known art historians for the Harvard Society of Contemporary Art.[2] Whether folk art is heatedly discussed or simply referred to today as amateur, country art, naive, nonacademic, popular, primitive, untutored, or vernacular (the term used for this exhibition) is philosophical at best; the aesthetic pleasure a piece of work gives is tantamount to its being locked into any limiting category.

The premier installation of American folk art was organized, also in 1930, by Holger Cahill at the Newark Museum in Newark, New Jersey. It was remounted two years later at the Museum of Modern Art in New York City where *American Folk Art: The Art of the Common Man in America, 1750–1900* was accompanied by an impressive catalogue of two hundred and twenty-five pages.

Successive museum and gallery exhibitions on the popular theme have been held regularly, with new scholarly information about unknown artists appearing in each accompanying catalogue. One of the most outstanding exhibits in recent memory was *The Flowering of American Folk Art, 1776–1876* at the Whitney Museum of American Art in New York City in 1974. The curators were two American art history doyennes, Alice Winchester and Jean Lipman, whose landmark exhibition with its powerful and romantic images re-established the popularity of American folk art two years before our country's bicentennial.

Other well-known scholars of American folk art include Frank O. Spinney, Beatrix Rumford, and Elizabeth V. Warren. Within the past ten years several pioneers have lamentably passed on, and it is to the memory of Mary C. Black, Robert Bishop, Joyce Hill, Louis C. Jones, and Nina Fletcher Little that this catalogue is respectfully dedicated.

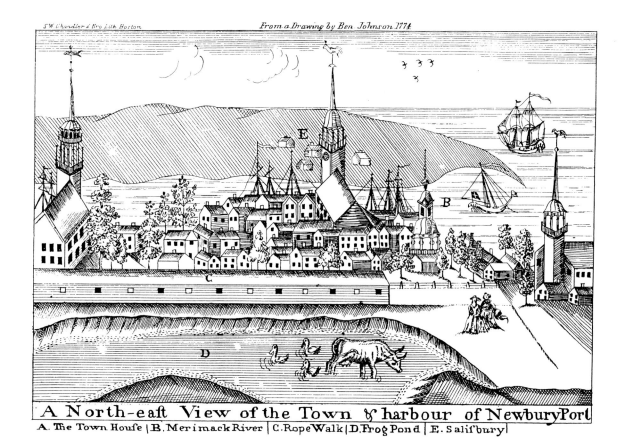

A North-east View of the Town & harbour of NewburyPort

A. The Town House | B. Merimack River | C. RopeWalk | D. Frog Pond | E. Salisbury

3 Landscape – "A North-east View of the Town & harbour of NewburyPort"
Artist unknown, after a 1774 engraving by Benjamin Johnston (1742–1818)
Photographic reproduction; the original drawing and engravings of the same are
no longer in existence.

An heraldic painter and engraver, Benjamin Johnston also colored, framed, glazed,
and sold his prints in Newburyport. The legends at the upper and lower margins
identify him, the Boston lithograph firm that reprinted the view in an early history
of Newburyport published in 1854, and important aspects of the colonial town.
In 1796, the visiting Dr. Timothy Dwight wrote that "Newburyport…is built on
a declivity of unrivaled beauty. The slope is easy and elegant; the soil rich, the
streets, except one near the water, clean and sweet; and the verdure, wherever
it is visible, exquisite."

References:
Joshua Coffin, *A Sketch of the History of Newbury, Newburyport, and West Newbury
 From 1635 to 1845* (Boston: Samuel G. Drake and George Coolidge), 1845,
 p. vii. (Hereinafter referred to as Coffin.)
Peter Benes, *Old-Town and The Waterside* (Newburyport: Historical Society of
 Old Newbury), 1986, p. 107. (Hereinafter referred to as Benes with caption
 references, and as OTW in the text.)

The Local Landscape

Approximately four meandering miles and one hundred and thirty-nine years of local history separate the 1635 landing place of the first settlers of "Newberry" on the Quascacunquen River from the townsfolk depicted in the earliest representation of colonial Newburyport in 1774 along the Merrimack River (3). In 1764, ten years before this panoramic print was offered for sale to the inhabitants, the enterprising merchants of the "Waterside" were successful in their six-month-old petition to the General Court of Massachusetts to break away from their agrarian "Old-Town" neighbors.[3]

Newbury has always remained rural (4), but the waterfront area in Newburyport, where Water and Merrimac Streets flow together, has been continuously developed as the downtown section. Here commercial interests of all sorts were located side by side with residential structures of both grand and humble proportions. During the Federal period, enlightened merchants who were accumulating wealth and prestige began to move away from this hustle and bustle. They chose the parallel but elevated two-mile road between Newbury and Newburyport, and on it, and adjacent side streets, they had built imposing structures and complementary gardens to rival those of stately Chestnut Street in Salem, Massachusetts.

The only significant change in downtown Newburyport's character occurred during the Great Fire of 1811, which decimated the landscape, and the only depiction of part of it can be seen in the print made the same year (2).

In 1840 the arrival of the Eastern Railroad enabled businesses such as boot and shoe manufacturing, which had heretofore relied heavily on shipping for the transportation of goods, to expand greatly.[4] The bas-relief of a train (6) depicts the close proximity of dwellings in downtown Newburyport as does the jumbled view of lower Green Street (5). These and other visually appealing landscapes record sections of Newburyport little changed to this day.

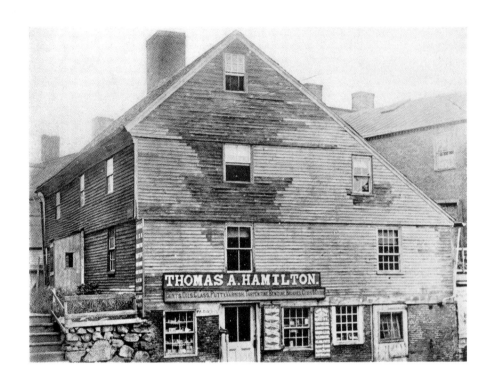

5a Photograph of Thomas A. Hamilton's home and business, showing his trade sign, ca. 1900

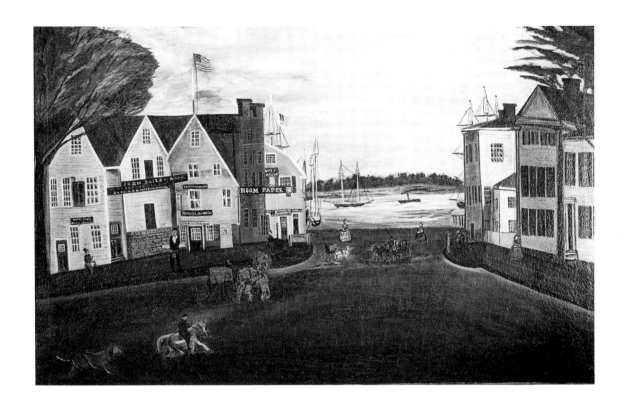

5 *Newburyport Harbor*
Thomas A. Hamilton (1838–1921), Newburyport ca. 1870
Oil on canvas, 19 3/4 x 32 inches
New York State Historical Association, Cooperstown

A carved and gilded eagle crest with trophies and leafage crest surmount this charming view of lower Green Street. Private residences on the right side of the street contrast with commercially oriented dwellings on the left side, identified by their trade signs. The gambrel-roof brick building at the intersection of Merrimac Street and Brown's Wharf is still a prominent landmark. This may be the only painting, or at least the only one known, by Thomas Hamilton, whose trade sign (5a) appears above the shop door and windows of his home and business located at 40 Green Street. The artist-shop owner sold "PAINTS. OILS. GLASS. PUTTY. VARNISH. TURPENTINE. BENZINE. BRUSHES. GLUES. COLORS." Beginning in 1858 Hamilton boarded where he worked at the Benaiah Titcomb house (ca. 1695), which he later purchased; around 1905 he moved to 2 Warren Street in Newburyport where he is mentioned in the city directory for the last time in 1912.

References:
Howells, p. 180.
Newburyport City Directories, 1858, 1867/8, 1905, 1912/13.

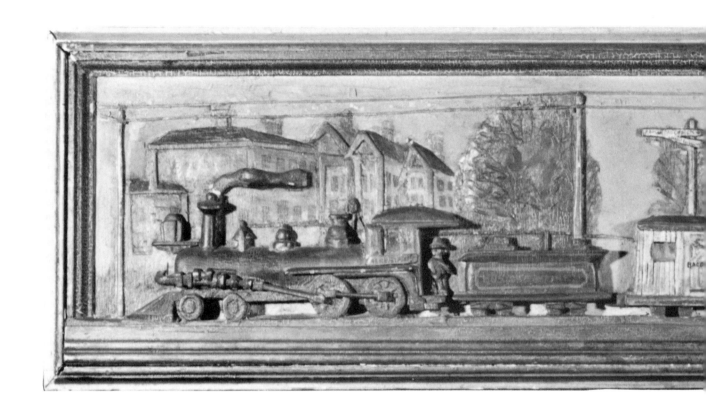

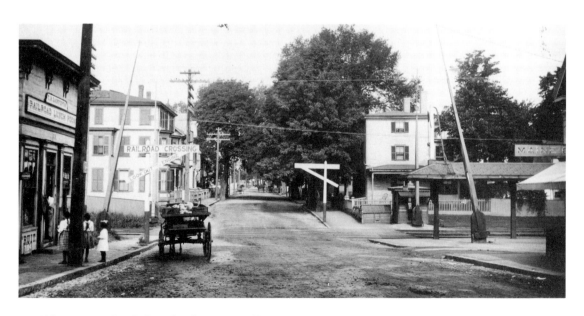

6a Photograph of the Newburyport Depot, ca. 1875–1885

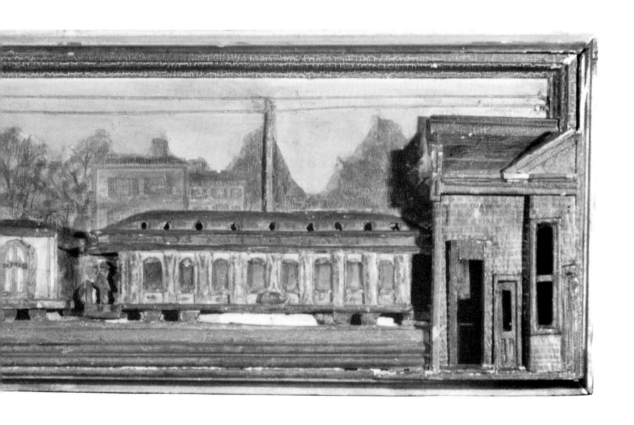

6 *The Boston and Maine Train in the Newburyport Depot*
Maker unknown, Newburyport, ca. 1875–1885
Polychromed carved wood, 12 x 44 inches
Private collection

Carved in high relief and framed much like a shadow-box picture, this unique
panel depicts a steam locomotive with its coal, baggage express, and passenger
car departing the train station formerly located near the corner of Washington
and Winter Streets. Architectural details of adjacent Federal period structures
correspond to those in late nineteenth century photographs of the area (6a).

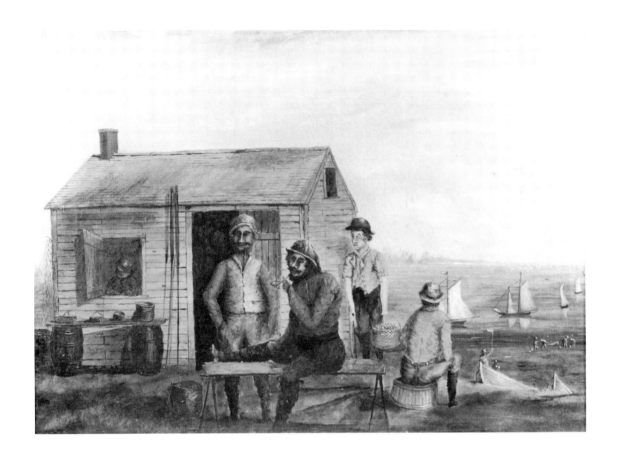

7 **"The Clammers/Joppa"**
William H. Swasey (1823–1915), Newburyport, 1880
Oil on canvas, 14 x 20 inches
Private collection

Wonderful character portrayals and a wealth of details document the simple
workdays of the Joppa Flat clam diggers of the late nineteenth century. Many
wooden shanties, like the one depicted here, once lined Flat Iron Point in Newbury.
Mr. Swasey ran a fancy-goods store in the 1870s, and he was a special partner
during that decade with shoe manufacturer Elisha P. Dodge. A benefactor of the
city, Swasey was elected treasurer of the newly formed Anna Jaques Hospital in
1883, and a few years later he was appointed treasurer of the Towle Manufacturing
Company. Little reference has been made to his artwork, which he evidently
enjoyed doing in the 1880s.

Reference:
Currier, John J., *History of Newburyport, Mass., 1764–1909* (Newburyport:
 Printed by Newcomb and Gauss, Salem, Massachusetts), 1909, pp. 399, 400.

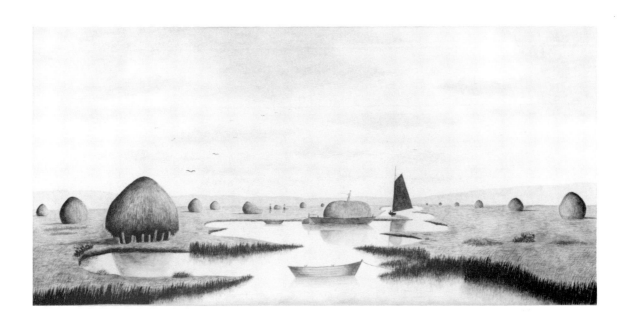

8 *Salt Marsh Haying With a Gundalow*
Artist unknown, probably Newburyport, ca. 1880
Watercolor on paper, 13 1/4 x 27 3/4 inches
Private collection

The scenic tidal marshes of Newbury have been painted by well-known visiting academic artists, such as Martin Johnson Heade (1819–1904), and by many local amateur artists. This sun-drenched view with its conflicting shadows is unusual in its depiction of a flat-bottomed gundalow. A nineteenth-century eyewitness to the harvesting of the salt marsh hay wrote that "The tedium of the summer work was relieved by the cutting, curing and boating the salt hay from the Plum Island marsh Towards the last of August or the first of September, according to the tides, the salt hay season began There was a sufficiency of hands to cut the grass before sunset. Having been left to dry for a day or so, another day was devoted to curing it; then came the boating The gondola laid at the foot of Whetstone Lane (West Newbury); if the weather proved auspicious the freight was usually at the landing in thirty-six hours. The neighbors turned out with their teams, and the hay was carted home, a distance of two miles, in a triumphant procession."

Reference:
Sarah Anna Emery, *Reminiscences of a Nonagenarian* (Newburyport:
 William H. Huse & Co.), 1879, pp. 58, 59.

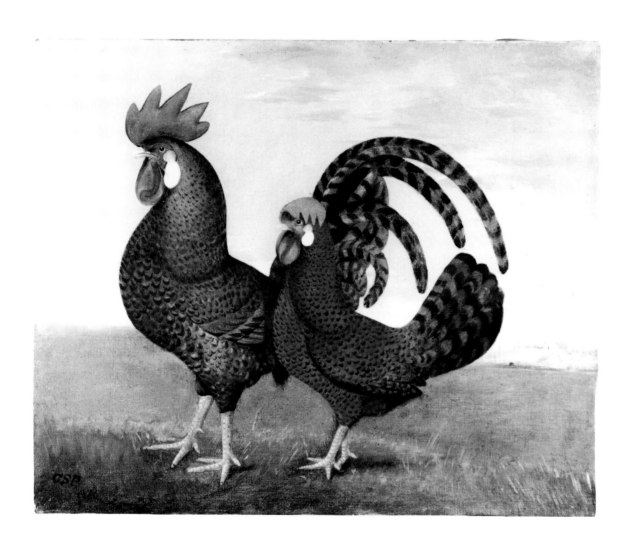

9 Dominique Leghorns
Artist unidentified, initialed and dated "C.S.P. / 1876," Newburyport
Oil on canvas, 22 x 27 inches

A handsome pair of domesticated exotic fowl (known by their gray, barred plumage, yellow legs, and rose-colored comb) pose side by side for their portrait, dwarfing the historic house and farm of Amos Little Leigh (1847–1921) on Leigh's Hill in Newbury, shown in the vignette in the right distance.

Memento Mori

It is generally agreed that the carving of effigies on gravestones in New England, be they demonic (10) or angelic (11), is the earliest type of folk art in America. During the late seventeenth and early eighteenth centuries, the wealthy ordered gravestones for their loved ones from Boston and Charlestown. Jonathan Hartshorne (born 1703), who had arrived in Old Town by 1742, may have been the first of several professionally trained carvers of gravestones in Newbury. [5]

Geometric decorations in the form of intersecting circles and squares often coexisted with nonstatic motifs such as swirling pinwheels and lozenges, surmounted by a primitive skull or soul image on many gravestones in local Newburyport area cemeteries. High, relief-carved, sensuous fruit in the baroque style of the late seventeenth and early eighteenth centuries was replaced by flat-carved wave and scrolling leaf designs in a vernacular rococo style.

With the arrival in America of the neoclassical style in architecture and the decorative arts in the late eighteenth century, there followed new mourning motifs, such as the plain or draped urn, weeping willow, and broken column, incorporated in embroidered and painted memorial pictures of the same period.

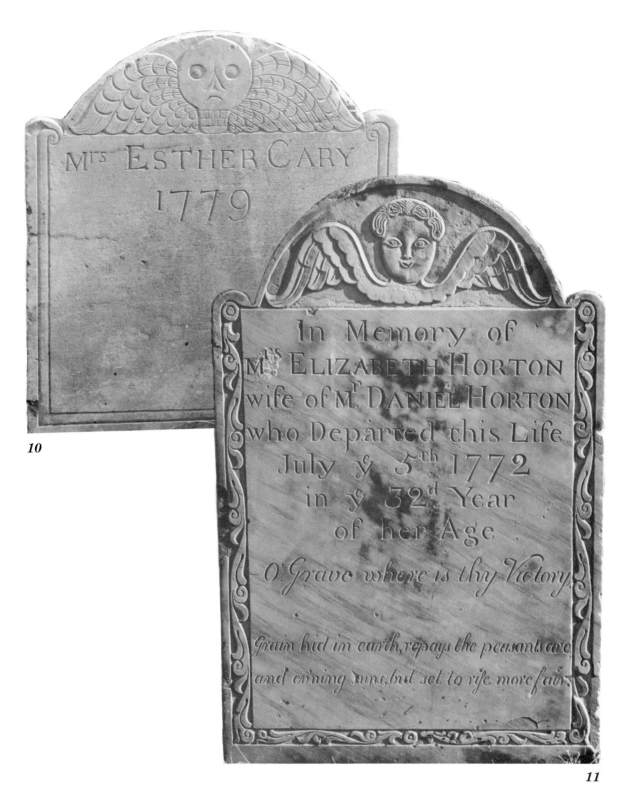

Mrs ESTHER CARY
1779

10

In Memory of
Mrs ELIZABETH HORTON
wife of Mr DANIEL HORTON
who Departed this Life
July ye 5th 1772
in ye 32d Year
of her Age
— O Grave where is thy Victory

Grain hid in earth, repays the peasants care
and evining suns, but set to rise more fair.

11

10, 11 *Gravestones in the Old Hill Burying Ground (and on preceeding page)*
Newburyport, established ca. 1729

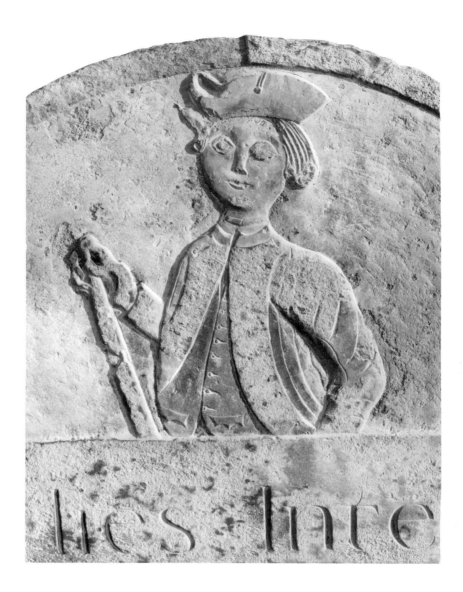

12 *Gravestone Effigy of Anthony Gwynn (1710–1777)*
Attributed to Henry Christian Geyer (active 1770–1790), Boston, ca. 1777–1778
Slate, 38 x 32 1/2 inches
Museum of Fine Arts, Boston; on permanent loan from
St. Paul's Church, Newburyport

The colonial gentleman depicted for posterity on stone represents Anthony
Gwynn, a wealthy British-born Newburyport merchant. Time and the elements
have slightly altered his bas-relief portrait and given the benefactor to St. Paul's
Church, in which burying ground he was interred, an unintended arthritic hand
to contrast with a youthful face.

Reference:
Benes, p. 178.

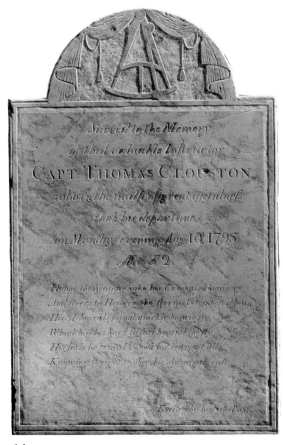

14

13 Maritime Mourning Picture (opposite page)
Thomas Clouston (1743–1795), Newburyport, 1777–1778
Watercolor and ink on paper, 14 3/4 x 10 1/4 inches

The upper half of this before-and-after grisaille picture depicts the locally owned ship *Hero* at full sail under the watchful eye of the man in the moon in a voluted crescent. The lower, very dramatic, half of the mourning picture made by crewman Clouston in memory of Jacob Knapp (1757–1777) shows the Revolutionary privateer vessel being capsized after clearing Boston Harbor. Born in Scotland, Thomas Clouston served as a volunteer crewman on the Newburyport brig *Dalton*, which was captured by the British in 1776. Incarcerated in the Old Mill Prison in Plymouth, England, Clouston and fellow Newburyporter Eleazar Johnson escaped and found their way back home. Capt. Clouston was so admired by his students in the local maritime academy that they erected a gravestone (14) carved with a sextant and respectful prose in his memory.

Reference:
Benes, p. 145.

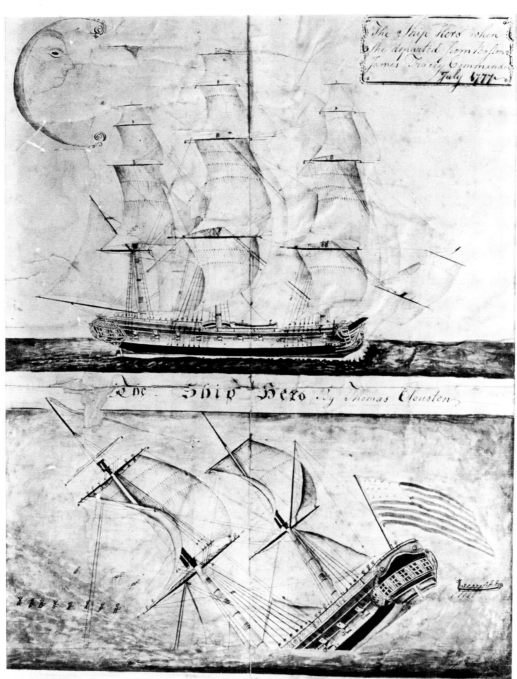

The Ship Hero when she departed from Boston James Tracey Commander July 1777

The Ship Hero By Thomas Clousten

In Memory of JACOB KNAP; Aged 20 who was Lost in the Hero; Commanded by J. Tracy.

13

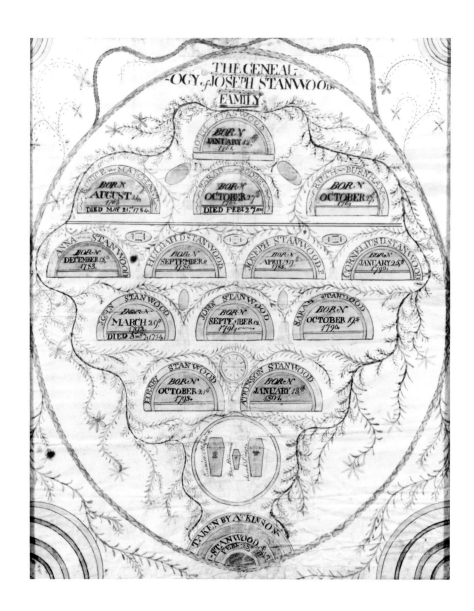

15 Family Register–"THE GENEALOGY of JOSEPH STANWOOD'S FAMILY"
Atkinson Stanwood (1801–1884), Newburyport, 1814
Watercolor and ink on paper, 14 3/4 x 12 inches

Undoubtedly influenced by geometric and decorative instruction he may have received in a public or private academy, thirteen-year-old Atkinson Stanwood embellished his sprightly egg-shaped family genealogy with trailing vines, smaller eggs, tassels, and a clock. This colorful compass-drawn birth and death record depicts the family's history in a decorative way.

Reference:
Benes, p. 45.

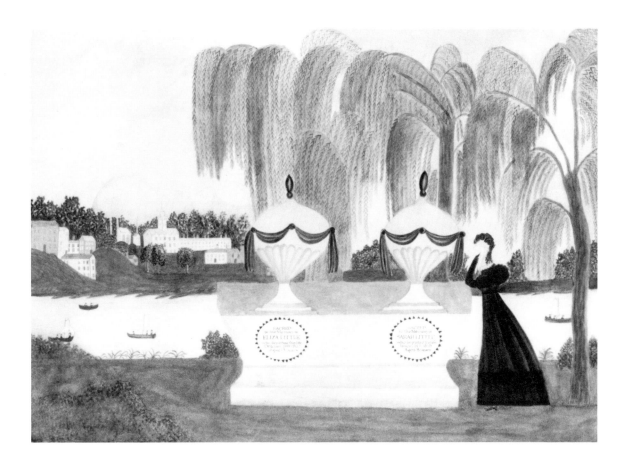

17 Memorial Picture
Artist unknown, Newburyport, ca. 1810
Watercolor on paper, 15 1/4 x 21 1/4 inches
Photograph courtesy of SKINNER, Inc.

Draped double neoclassical urns have similar inscriptions sacred to the memories of Eliza Little, who died in 1802, and her younger sister, Sarah, "who departed this life" at the age of eight years in 1810. Their mother, Hannah Brown Little, is lamenting her losses in this sentimental scene with weeping willows, boats on the river, and an imaginary townscape visible in the background.

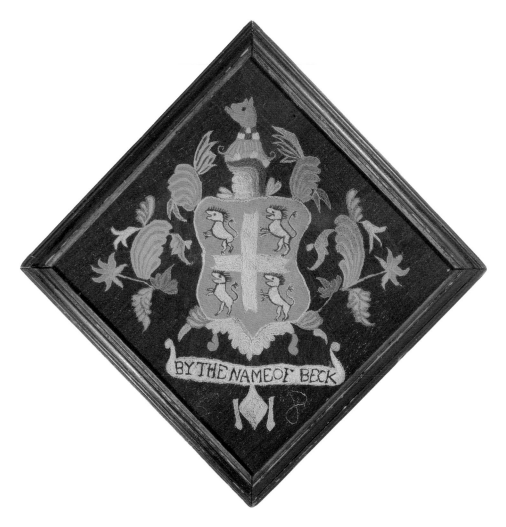

18 *Crewelwork Coat of Arms*
Abigail Daniel Beck, Newburyport, ca. 1768
Polychrome wool and silver metallic thread on linen, 14 3/4 inches square

Vibrant wool or crewel yarns of flowers and leaves flank this unique hereditary or pseudo-armorial shield of the Beck family, still in its original lozenge-shaped ebonized frame. According to the somewhat involved and confusing history written by a descendant on the accompanying label, "This coat-of-arms was worked by my great grandmother Hannah Beck (wife of Deacon Jonathan Beck of Newburyport) whose maiden name was Hannah Daniel, in her 68th year as outlined upon it" More than likely, the silver metallic thread numerals pertain to the year in which the piece was worked. Sarah Anna Emery wrote that "Coats of arms were also embroidered in white satin with colored silk . . . Miss Peabody's was framed in gilt, in an oval of enamel, with gold stars in the center."

References:
Conversations and correspondence with needlework authorities Glee F. Krueger
 and Betty Ring, March, 1994.
Emery, p. 223.

28

88 Painter's Trade Sign
Maker unknown, Newburyport, 18th century
Polychromed wood with painted gold and silver highlights, 27 inches diameter

Green Davis (1849–1923), the master of St. John's Masonic Lodge in 1882, used this repainted eighteenth century trade sign for his business on Merrimac Street. Representing British arms of the painters and stainers guild, the sign may have originally been used by Benjamin Tucker (1768–1832), who offered "a generous assortment of Painters Colours . . . at his shop, sign of the PAINTERS ARMS, State Street Newburyport" during the late eighteenth century.

References:
Benes, pp. 92, 93.

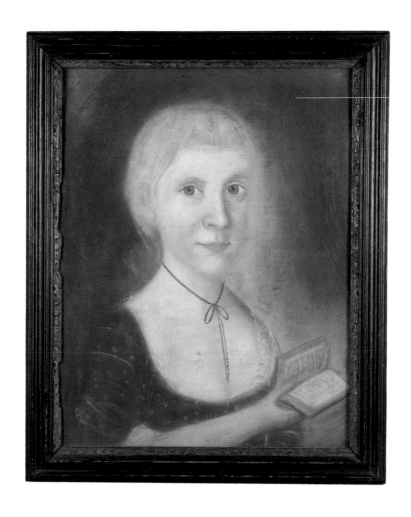

19 *Portrait of Molly Hoyt (1773–1846)*
Attributed to Benjamin Blyth (ca. 1746–1787), Newburyport, ca. 1780
Pastel on paper, 16 1/2 x 13 inches (sight)
Private collection

A captivating smile and eyes that seem to follow you around the room aptly describe the delicate likeness of the late eighteenth century Newburyport girl holding her favorite book. Molly was the daughter of Moses and Mary Stickney Hoyt, and her portrait was probably framed by the Salem artist or his brother, Samuel Blyth (1744–1795). The only other Newburyport pastel portrait with a scholarly attribution to the hand of Benjamin Blyth is that of the Rev. John Murray (HSON collection).

References:
Nina Fletcher Little, "The Blyths of Salem: Benjamin, Limner in Crayons and Oil, and Samuel, Painter and Cabinetmaker," *Essex Institute Historical Collections*, January, 1972, pp. 50, 54, 57.
Benes, p. 148.

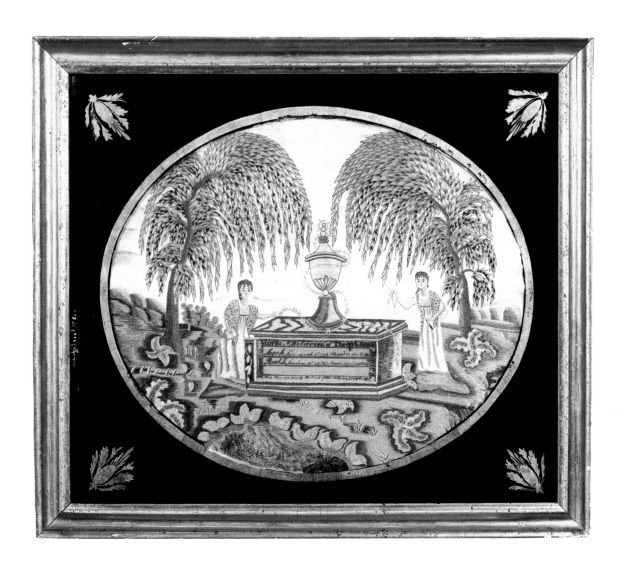

16 *Mourning Picture*

Mary Jaques (born 1799), Newburyport, 1819
Polychrome silk thread with ink and watercolor on silk, 15 1/2 x 18 1/2 inches

Following a standard Federal-period memorial picture composition, Mary Jaques used an oval format for this memorial to her brother, Paul Thorla Jaques, who died on the island of Java. It is not known if Mary painted the faces of the two mourners, which may have required the hand of the more talented perceptress. The picture is in its original églomisé mat with stylized silver-leaf corner spandrels and lemon gold molded frame.

Reference:
Benes, p. 147.

A Boarding School

ELEANOR DRUITT, most respectfully acquaints the public, that she intends opening a Boarding, and Day-School, for the reception of young Ladies; near the Assembly-House, on Monday the 28th of October; she will instruct them in the English and French Languages Grammatically, and all sorts of needle-work, viz. such as plain sewing, embroidery and Tambour &c. her terms for boarding will be moderate : She assures those who are pleased to entrust her with the care of their children, that she will exert her utmost abilities to please.

N. B. Drawing, mending rich laces, darning &c. dispatched with fidelity; on the most moderate terms and shortest notice.

Newbury-Port, October 25.

Essex Journal, October 25, 1776

SCHOOL.

MARY EMERSON intends to open a School in Boardman-street, at the house of Capt. THOMAS BOARDMAN, the 2d Monday in April, for the instruction of Reading, Spelling, Sewing, &c. march 27.

Newbury port Herald, March 27, 1812

JAPANNING.

MARY S. BROWN informs the ladies of Newburyport and vicinity, that she will give Lessons in the art of Japanning, should she meet with encouraging patronage, which she respectfully begs leave to solicit.— Specimens may be seen at the bookstore of Mr. Ebenezer Stedman, or at the residence of Capt. I. Stone, Market Street.

Terms, one dollar each lesson. nov 30

Newburyport Herald, November 30, 1830

SCHOOL.

MARY-ANN COLMAN informs her friends and the public, that she continues her SCHOOL in *Fair-Street*, for the instruction of Young Ladies and Misses in Reading, Writing, English grammar, Geography, Drawing, Painting, Useful and Ornamental Needlework.—Those who may intrust the Tuition of their children to her care, may be assured that no pains on her part, will be spared, to give satisfaction. Feb 25.

Newburyport Herald and Country Gazette, February 25, 1812

SCHOOL.

MRS. PAGE would inform her friends and the public, that she has removed her School to the room formerly occupied by Miss N. Jackson, in State-Street, where she continues to teach all branches as usual.— Mrs. P. has furnished herself with new and fashionable patterns for *Rugs, Counterpanes, Crickets, &c.* Terms from two to four dollars per quarter. q march 22

Newburyport Herald, March 22, 1825

MR. ROBINSON,

CONTINUES his school at the School-House in Harris-street, where he instructs scholars of both sexes in Reading, Spelling, Writing, Arithmetic, English Grammar, &c. A lady will soon commence instructing the Misses in Needlework, Drawing and Painting, three afternoons in a week. (q) march 22.

Newburyport Herald, March 22, 1825

Nonacademic Academy Art

Formal mentor-to-student art training received by young American men has been termed "academic" by art historians, in contrast to the creative output of girls and young ladies of privilege which falls into the category of "nonacademic." Amusingly, these females learned their various decorative and some social skills at so-called academies and seminaries!

From the late eighteenth to approximately the mid nineteenth century, these schools, almost always held at the preceptress's or master's home or rented space, were located in practically every town or city of culture and commerce. In Newburyport, at least twenty-four teachers taught their students how to paint free-hand landscapes on paper and furniture (47), how to stencil fruit and flowers on velvet (31) and paper (32), and how to memorialize departed family members on silk (16). Of particular importance to her future role as a wife and mother, a young lady was taught how to sew and learn the alphabet by embroidering a verse of wisdom on her own sampler (20, 21).

Although she does not mention her mother Sarah Smith Emery (1787–1879) as having attended an academy, Sarah Anna Emery (1821–1907) of Belleville wrote that "At each of the female schools, in addition to knitting and plain sewing, ornamental needlework was taught, and in some, instruction was given in drawing in India ink and painting in watercolors; also, every girl was taught to embroider letters in marking stitch. One was considered very poorly educated who could not exhibit a sampler In my childhood Marm Dod and Miss Phillipa Call were famed instructresses. Mrs. Catherine Wigglesworth Brown . . . had a large and genteel school for several years in Newburyport." [6] The first preceptress to teach embroidery skills locally was the European-born itinerant Mrs. Eleanor Druitt, who arrived in 1775 after having worked in Boston.[7]

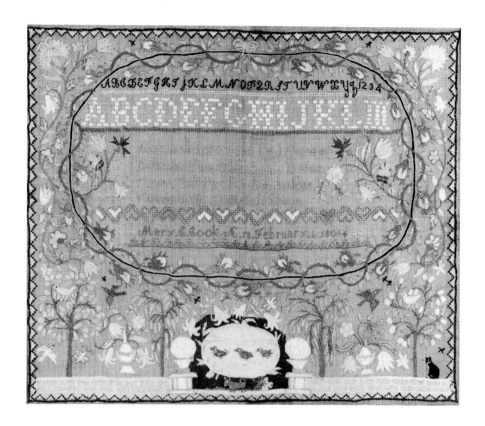

20 Sampler
Mary Caswell Cook (born 1788), Newburyport, 1801
Polychrome silk on linen, 18 1/4 x 21 7/8 inches
Private collection

The brick wall with oversize ball-and-urn gateposts depicted here is an unusual feature in the repertoire of embroidered samplers worked in Newburyport. It is one of approximately fifteen identifiable examples of the "shady bower" group, the earliest and most detailed having been made in 1799 by twelve-year-old Sarah Johnson (OTW, pp. 174, 175). Two closely related "pond with ducks" samplers, by Sally Frost Blunt (1800) and by Mary Coffin (1801), have the same ellipse and sawtooth border but include a fisherman and other people. Mary Emerson has been identified as the preceptress of this particular school, which she taught until 1812. In her newspaper advertisements Emerson confidently stated that she taught every kind of needlework including the uncommon grotto and tambour varieties. "Private schools were extensively patronized. Those for young children were usually taught by middle aged or elderly women, in cap and spectacles," wrote Sarah Anna Emery. "There were Dame Moody, Marm Emerson, Marm Fowler at Belleville, and others." A twin daughter of Zebedee and Sarah Cook, Mary included her favorite black-and-white cat in the composition, shown perched on the garden wall not too far from the unobservant ducks swimming in the lily-encircled pond.

References:
Emery, p. 222.
Conversation with Glee F. Krueger, March, 1994.

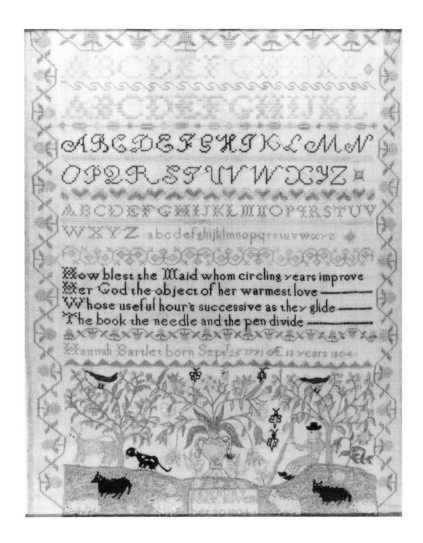

21 Sampler
Hannah Bartlet (born 1791), Newburyport, 1804
Polychrome silk on linen, 21 x 16 1/2 inches (sight)

A seated shepherd on a hillock is minding his flock of black-and-white sheep along with a beige cow and his black dog in thirteen-year-old Hannah's embroidered sampler. Her parents, Richard and Hannah Bartlet, must have been proud of their daughter's work which she inscribed at the base "NEWBURY/PORT/NOVEM/ber 30 1804." A stern critic of embroidered pictures wrote that some " . . . were quite pretty specimens of needle work; but sometimes, when more ambitious attempts were exhibited, they were sufficiently grotesque. I have seen wrought under the letters, a square, three-storied house flanked by a pot of flowers, the pot, and what was intended for a rose bush, as tall as the house, with a horse on the other side twice as large as either."

Reference:
Emery, pp. 222, 223.

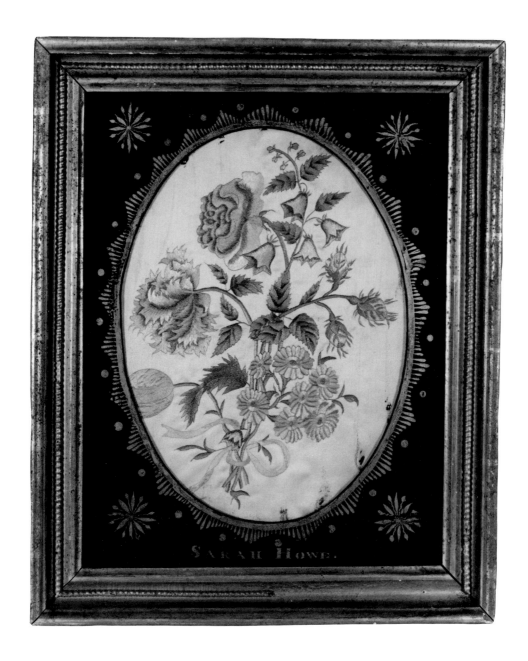

22 *Embroidered Floral Picture*
Sarah Howe (1792–1831), Newburyport, ca. 1810
Polychrome silk on silk, 13 1/2 x 10 1/2 inches

An accomplished preceptress with skill in verre églomisé, or a local framemaker, probably painted the name and gold-and-black decoration on the reverse of the glass to serve as a mat for Sarah Howe's naturalistic portrayal of a summer bouquet.

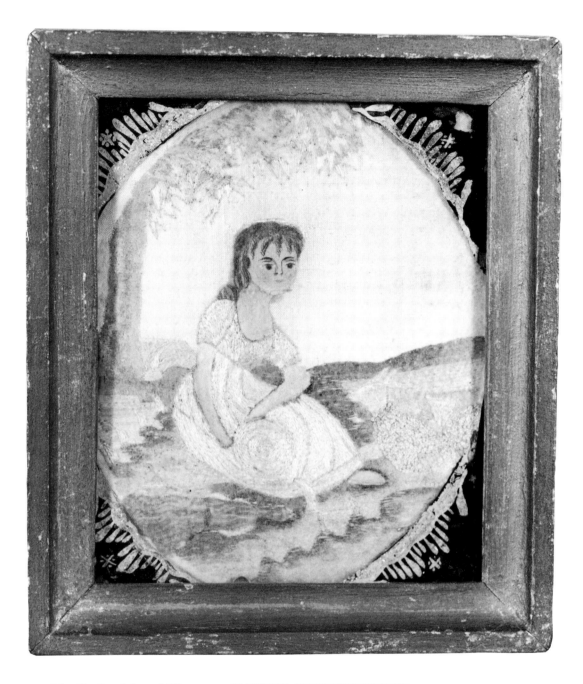

23 Embroidered Picture – "LITTLE SHEPHERDESS"
Eunice Jaques (1794–1847), Newbury, ca. 1809
Polychrome silk and paint on silk, 4 1/2 x 3 3/4 inches

This diminutive portrayal of a young girl in a needlework landscape is still in its original églomisé mat and gilded frame. Eunice Jaques Haskell gave this "worked" embroidered picture to her daughter, Mary Haskell Woodwell, "To be taken care of." Mrs. Woodwell's signature appears on the dust cover with the notation that she had reached the advanced age of 104 years on August 9, 1929.

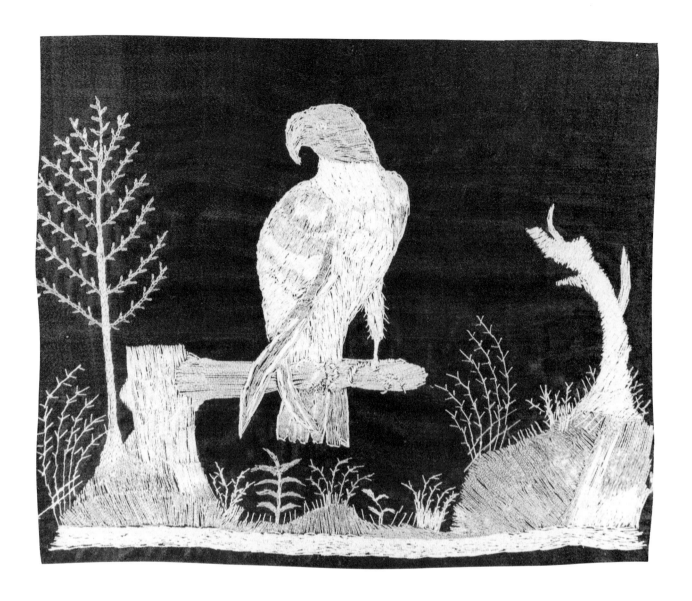

24 *Embroidered Parrot Picture*
Maker unknown, Newburyport, ca. 1780–1810
Polychrome silk on silk, 9 1/2 x 11 1/2 inches

Paired facing parrots appear frequently as a popular motif on local vertical-format
linen samplers sewn during the last decade of the eighteenth century (OTW, pp. 69,
70, 136). This single parrot, perched in its own landscape on a black background, was
embroidered by a member of Edmund Bartlet's family, who lived at 3 Market Street.

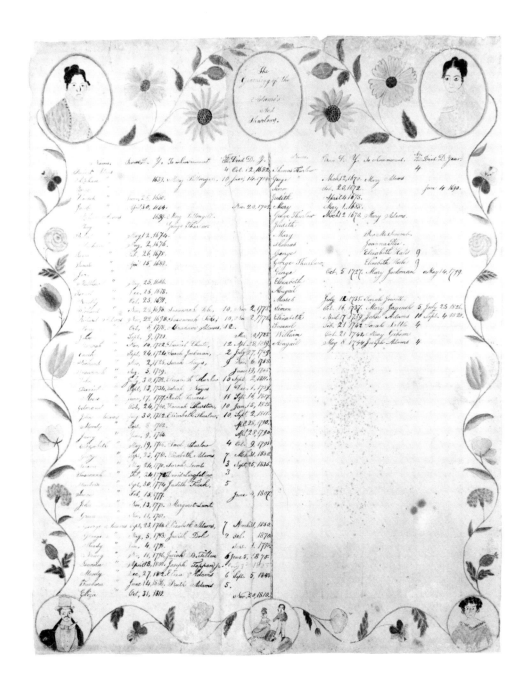

25 Adams–Thurlow Family Register
Unknown artist, Newbury Farms area, ca. 1825–1835
Watercolor and ink on paper, 23 1/2 x 18 1/2 inches
Private collection

Meandering naturalistic vines with mixed flowers connect corner miniatures
of individuals in colorful Empire-period apparel. This is probably the largest
handmade genealogical chart associated with Newburyport families.

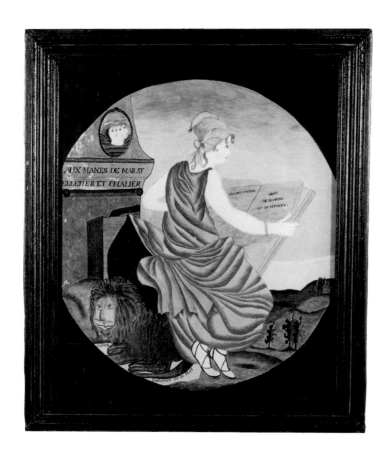

26 Symbol of the French Liberated Woman
Charlotte Chandler Tenney (born 1815), Bradford, Massachusetts, ca. 1833
Watercolor and ink on paper, 10 1/2 x 9 inches
Private collection

An unidentified pictorial source of the French Revolution (1789–1799) served as the prototype for this neoclassical circular vignette of a liberated Frenchwoman, probably relating her to the 1791 Declaration of the Rights of Women. Wearing a cocarde to complement her free-flowing robe, the maiden is holding the tome on the French Constitution and the Rights of Man and Citizen. The monument is inscribed to the memory of Jean Paul Marat (1743–1793), the well-known Swiss-born Revolutionary leader and journalist who was murdered in his bath by Charlotte Corday (1768–1793). Also included are the names of Joseph Chalier (1747–1793), a Jacobian chief of the Montagnards from Lyon, and possibly that of Joseph Pelletier (1788–1842), a noted chemist and pharmacist. "Liberty" is inscribed under the humanized face of the lion, and "Brotherhood or Death" is written under his tail.

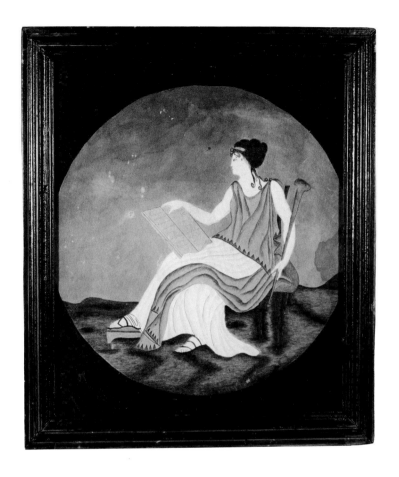

27 *Symbol of a Roman Woman*
Charlotte Chandler Tenney (born 1815), Bradford, Massachusetts, ca. 1833
Watercolor and ink on paper, 11 x 9 1/4 inches
Private collection

Good color, linearity, and volume were used by Miss Tenney (later Mrs. Daniel Kimball) to produce her pictures, still in their original frames. She entered Bradford Academy, the largest school in the greater Newburyport area, in 1823. Founded twenty years earlier for the education of young men and women, only females were admitted after 1836. "Beside the instruction in the higher English branches, considerable attention was bestowed in (the female) department on embroidery, a kind of sketching upon satin by means of needle-work, then much in vogue. Proficiency in this art was at the time esteemed an essential part of a young lady's education" Inscribed in her open book "In the year/109 the temple/of Janus was/shut, which/very/ rarely hap/pened in/Rome, but/upon/the/breaking out/of New Wars,/was presently/open/again./The [indecipherable] the Sardin/and the Corsi/were subdued."

Reference:
Semi-centennial Catalogue of the Officers and Students of Bradford Academy,
 1803–1853 (Cambridge: Metcalf and Company), 1853, pp. vi, 80.

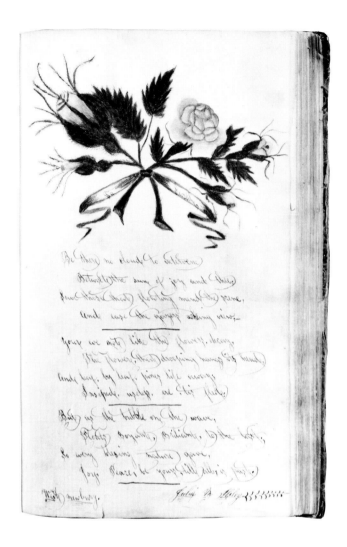

28 Poetry Album
Sarah Dole (1810–1892), Newbury, 1826
Watercolor and ink in a leather-bound book, 7 3/4 x 5 inches

Two school-age friends and members of Sarah Dole's family included small rose bouquets with their poetical sentiments in her album bound in red morocco leather. Another friend, Julia M. Ilsley of West Newbury, painted this dominant pink moss-rose bouquet. A person identified only by initials inscribed the last page with a penned flourish: "Next to a clear conscience, is a well-fill'd/ALBUM." In 1819, at the age of nine, Sarah created a polychrome silk on linen sampler (OTW, p. 71) with religious verse and typical local motifs including large-scale flowers, small animals flanking a plaited basket of flowers but minus the ubiquitous parrots. Sara Dole's mother paid preceptress Hannah Upham $10.00 in October of 1826 for "instructing Sarah & Ann twelve weeks."

Reference:
Separate wove paper receipt in album, 3 3/4 x 8 inches.

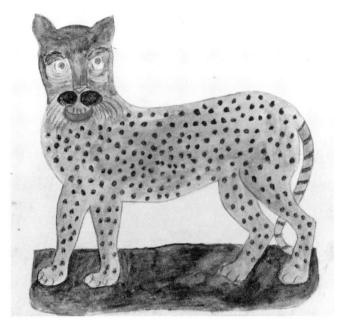

29

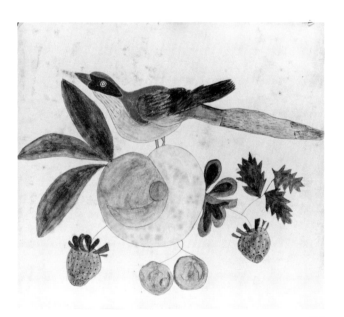

30

29, 30 *Watercolors of a Leopard and a Bird with Fruit*
William Hale, Jr. (1820–1910), Newburyport, ca. 1835–1845
Pigment on paper, 4 7/8 x 5 3/8 inches; 6 3/4 x 7 1/4 inches
Private collection

These captivating sketches accompany other delightful small renderings in an album filled with local and foreign newspaper clippings of the nineteenth century.

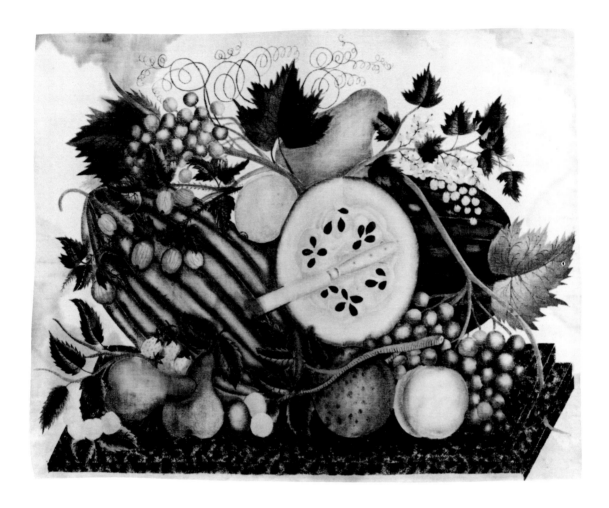

31 Still Life Theorem
Artist unknown, probably Newburyport, ca. 1825–1840
Polychrome pigment on velvet, 18 1/2 x 23 1/4 inches

The edible delights of summer are displayed in an intricate composition with strong coloration in this theorem.

32 *Theorem-type Still Life*
Artist unknown, probably Newburyport, ca. 1835
Watercolor on paper, 11 1/2 x 9 1/4 inches

Pinprick work and varnish give dimension, shadow, and texture to this expertly hand-painted still life that resembles a theorem.

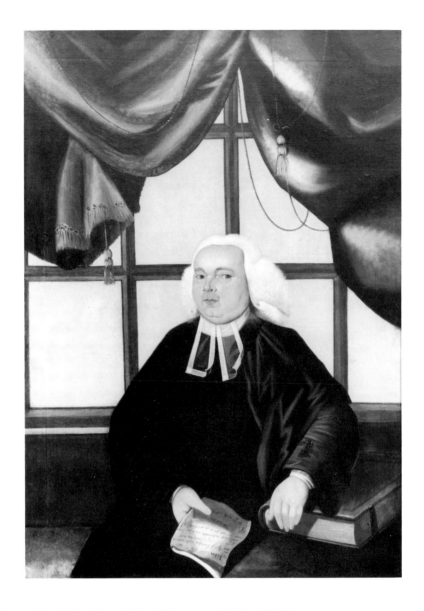

33 *Portrait of the Rev. John Murray (1742–1793)*
Attributed to Christian Gullager (1759–1826), Newburyport, ca. 1786–1789
Oil on canvas, 55 x 40 inches (sight)

The imposing three-quarter-length portrait of the bewigged Rev. John Murray probably depicts him seated in front of the pulpit window of "Old South" with a voluminous, swagged window hanging complementing his pyramidal girth. His left arm rests on a large leather-bound Bible, and in his right hand is a sermon he delivered from "John III 16." The Rev. John Murray was an "animated preacher, and the able defender of the gospel. His death was triumphant."

Reference:
Benes, p. 148.

Piety and Masonry

By the late 1780s, when the Rev. John Murray (1742–1793) posed for his portrait painted in the "Old South" Presbyterian Church (33, 98), three other houses of worship had been established in Newburyport: the Third Parish of Newbury (Congregational, 1725); St. Paul's Church (Episcopal, 1742); and, North (Congregational, 1768). The Rev. Murray preached "damnation" to his flock at the Federal Street church, while during the first quarter of the nineteenth century "there were many itinerant preachers consecrated to missionary work; these travelled on foot, their clothing slung in a knapsack on their shoulders or on horseback, the saddle-bags depending from the saddle containing the sum of their worldly possessions."[8]

Freemasonry is related to religion in many aspects—friendship, morality, and brotherly love. Introduced into the United States in Boston in 1733, it flowered in Newburyport in 1766 with the founding of St. John's Lodge.[9] Once located in the Phoenix Building on State Street, the lodge contains many interesting artifacts of a "folk" quality. Mrs. Emery wrote that "There were three Masonic lodges: St. John's, St. Peter's, and St. Mark's. When I was a child the brethren often assembled at Mr. Samuel Bartlett's residence. They occupied the front chamber, where they would keep up a most tremendous racket until a late hour."[10]

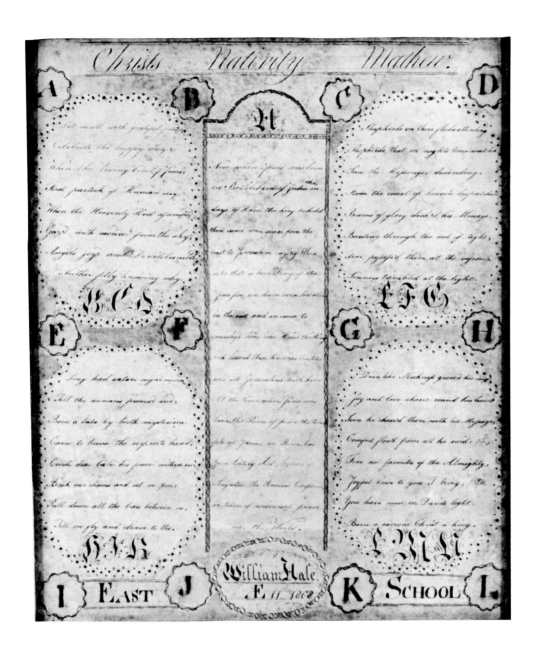

34 Religious Copybook Exhibition Piece
William Hale (1796–1857), Newburyport, 1808
Watercolor and ink on paper, 16 x 13 1/2 inches
Private collection

William Hale was an accomplished young artist, and many examples of his artwork still exist in family albums and scrapbooks. This large piece is more graphic than some of his other drawings and shows his interest in penmanship; it features neoclassical flourishes with Latin and Greek letters which enliven the religious quotations and verses.

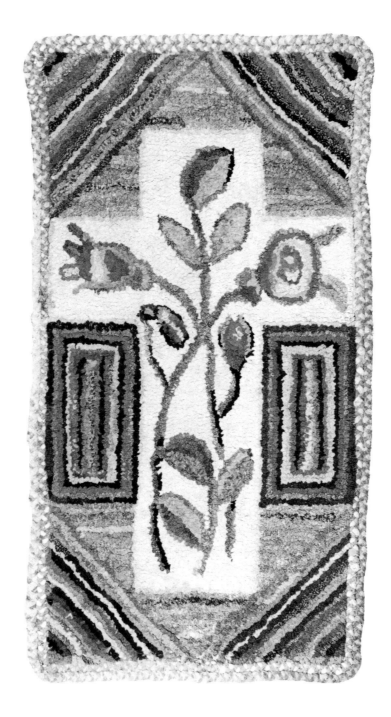

35 Hooked and Braided Rug
Maker unknown, probably Newburyport, late 19th century
Polychrome wool, 20 1/2 x 37 1/2 inches

This small, religiously inspired rug is related in design and color to other hooked examples by the same unknown maker in the society's textile collection.

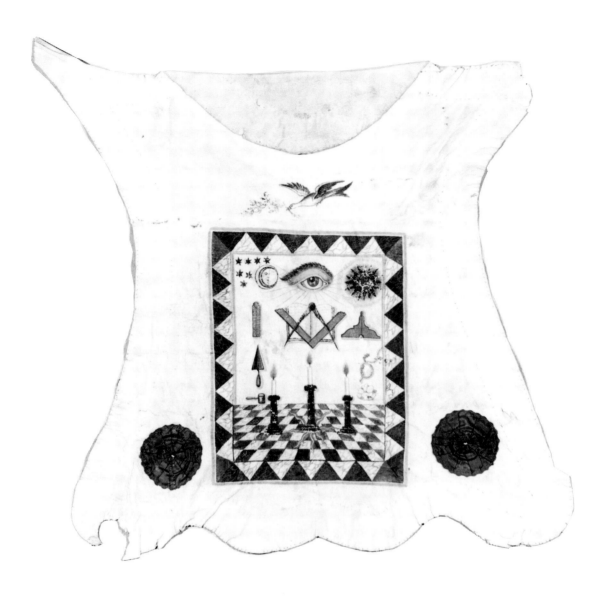

36 *Masonic Apron*
Artist unknown, Newburyport, ca. 1780–1800
Painted kidskin with satin, 19 inches x 19 inches
Newburyport Masonic Temple Association

Unusual for being in the shape of a flayed hide, this early, white kidskin apron (symbolizing innocence and purity) has geometrical and architectural motifs which represent the moral tenants of Freemasonry. These graphic symbols are associated with stonemasons of ancient history and convey moral and philosophical teachings to the lodge members. The design on this apron is referred to as a "tracing board" or "flooring"; it is flanked by olive green satin rosettes with a dove at the apex, an early symbol for a senior deacon in use in American Masonry.

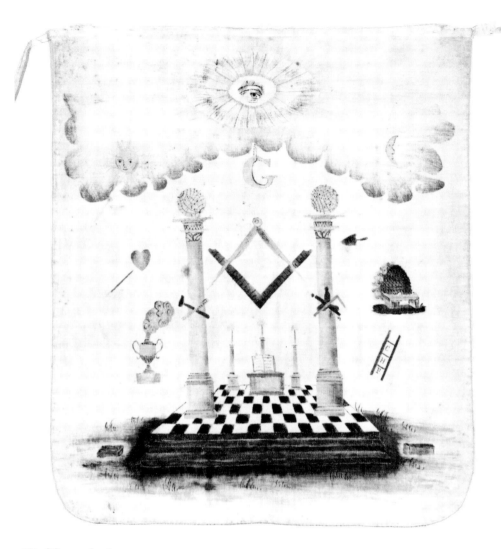

37 *Masonic Apron*
Artist unknown, Newburyport, ca. 1820–1830
Watercolor with silk on velvet, 17 1/2 x 15 1/4 inches
Newburyport Masonic Temple Association

An unidentified local artist painted this colorful theorem apron which has remnants of a sewn light blue silk ribbon. Hand-painted and embroidered Masonic aprons were the norm during the last third of the eighteenth century; by the early nineteenth century printed silk aprons became available. The Portsmouth, New Hampshire, artist John S. Blunt (1798–1835) charged between $1.75 and $2.25 for Masonic aprons he painted in 1826.

Reference:
Clement M. Silvestro and Barbara Franco, *Masonic Symbols in American Decorative Arts* (Scottish Rite Masonic Museum and Library, Inc.), 1976, p. 24.

John Brewster,

Portrait and Miniature Painter,

Respectfully informs the Ladies and Gentlemen of Newburyport, that if they wish to employ him in the line of his profession, he is at Mr. JAMES PRINCE's, where a specimen of his Paintings may be seen. He flatters himself, if any will please to call, they will be pleased with the striking likenesses of his, and with the reasonableness of his prices.

N. B. If there is no application made to him within ten days he will leave town. Dec. 5.

Newburyport Herald, Dec. 25, 1801

PORTRAIT PAINTING

THE subscriber respectfully informs his friends and the public that he will execute Portrait Painting in Oil Colours, as large as life, at the moderate price of five dollars for a front and two dollars and fifty cents for a side view. Those who wish to obtain such valuable furniture (exempt from taxation) will do well to call soon, as he intends removing in a few months to the metropolis, if sufficient encouragement is not received here. All who are unacquainted with his pretensions as an artist, may be satisfied by calling at his shop in Essex-Street, where may be seen several pieces of painting from his brush. Also, he continues to frame Ladies' Needle-work, Looking-glasses, &c. Sign and ornamental Painting done in style on the shortest notice. MOSES COLE.

Newburyport, Sept. 19, 1815

Newburyport Herald, Sept. 19, 1815

Colour Store.

B. TUCKER

Informs his friends and customers that he has constantly for sale at his shop, sign of the PAINTERS ARMS, State Street Newburyport—a general assortment of Painters Colours, wholesale and retail, either dry or ground in Oil—viz.

White Lead	Spruce Yellow
Whiting	Lump Yellow
Flake White	Stone Yellow
Red Lead	Naples Yellow
Venetian Red	Patent Yellow
Spanish Brown	Dutch Pink
Drop Lake	Umber
Vermillion	Prussian Blue
Purple Brown	Strowing Smalt
Rose Pink	Ivory Black
Verdigris	Lamp Black, &c. &c.
Sap Green	

ALSO,

Brushes, Pencils, and tools of all sizes, Copal Varnish, Black and white Ship Varnish, London and Philadelphia Linseed-oil, Spirits Turpentine, Glaziers Diamonds, Gold, Silver, and Brass Leaf, Window and sheet Glass, Glue, Litharge, Pumice Stons, Stone and Pallet Knives, all sizes, Putty for windows or joining glass and crockery ware, white Vitriol, Water colours in boxes, Hatt cases, &c. &c.——Painting, Gilding, Glaizing and Varnishing carried on in all their branches with neatness and dispatch.

An apprentice wanted at the above Store.

December 27.

Impartial Herald, Feb 3, 1797

Federal Folk Faces

During the colonial period, wealthy Newbury residents relied upon Boston artists for their portraits much as they did on the capital area's stonecutters for their gravestones. Local self-taught artists lacked talent in the early to mid eighteenth century and, for the most part, were not recorded for posterity.

New artistic blood and ideas arrived in Newburyport from Copenhagen around 1786, the year in which Christian Gullager (1759–1826) married local widow Mary Selman. While living in the town for at least three years, Gullager painted the likenesses of at least five residents using his favored three-quarter-length format (OTW, p. 118).

Evidently little influenced by Gullager's presence, Benjamin Tucker (1768–1832) was recognized as an early local artist. Neither competent nor prolific as a portraitist or landscapist, Tucker did produce a pen-and-ink drawing around 1796 entitled "N E PROSPECT OF THE TOWN OF NEWBURYPORT," which is the second earliest known view of the seaport (OTW, p. 93). Tucker also operated a painting, gilding, and varnishing shop located at the sign of the "PAINTERS ARMS" (88) on State Street.[11]

Around the turn of the nineteenth century, itinerant artists or limners (an eighteenth century term still used by art historians) became visible, though transitory, features in large towns, where they sought portrait commissions. The most famous to leave his mark in Newburyport was the deaf-mute artist John Brewster, Jr. (1766–1854), whose imposing portraits of four members of the affluent Prince family (38, 39, 40, 41) are veritable icons in the history of American folk art. Brewster appears to have lived for a while in the State Street mansion of James Prince (1755–1830) between November of 1801 when he painted the portraits and the following month when he advertised in the *Newburyport Herald*, and in January of 1802 when he advertised in the paper for potential customers to view a "Specimen" of his work.[12] Brewster was back in Newburyport in 1809, taking up residence in another home and probably completing more portraits.

(continued on page 56)

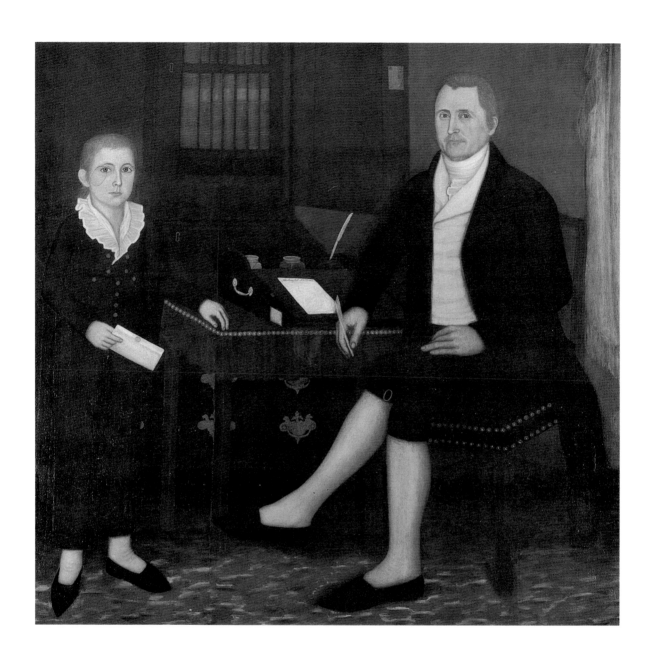

38 *Portrait of James and William Henry Prince (opposite page)*
John Brewster, Jr. (1766–1854), Newburyport, 1801
Oil on canvas, 60 3/8 x 60 1/2 inches

Interior details of the Georgian-style brick mansion of the Prince family were carefully rendered by Brewster and document the family's apparel, furniture, upholstery and window treatments, floor coverings, and accessories in vogue in Newburyport during the late eighteenth century. The long life of the Connecticut-born itinerant artist has been well chronicled. Brewster's appearance locally is corroborated by the inscription and date on the letter Mr. Prince is writing, "Newbury Port Nov. 25, 1801" (38a), and by his advertisements in the town's newspaper.

38a *Detail (above)*

Another itinerant artist who recorded the faces of several Newburyport citizens of the new republic was William Jennys (active 1795–1807). His oil portrait of Mary Bartlett Somerby (1731–1819) shows great character in the septuagenarian's countenance and composure (44), as the portraits of Dr. John Brickett (1774–1848) and his wife, Elizabeth (1777–1807), painted by Jennys around 1805–1807, show youth and romance (42, 43).

Working in a much smaller format than the previously mentioned artists, and preferring cardboard and paper to canvas, Moses Dupre Cole (1783–1849) focused his talent on bust-length portrayals. Cole, who was born in Bordeaux, France, emigrated from the French West Indies to Newburyport in 1795, but he evidently did not begin to paint portraits until late in the year 1815.[13] The artist's wife, Sarah Avery Cole (1782–1874) of York, Maine, was a framemaker, and she may have provided the simple gilded frames for the portraits of Newburyport innkeepers, Thomas Perkins (1773–1853) and his wife, Elizabeth (1778–1864) (45, 46). Three Cole sons, Joseph Greenleaf (1806–1858), Lyman Emerson (1812–ca.1878), and Charles Octavius Cole (born 1814) followed in their father's artistic footsteps and were local portraitists during the mid nineteenth century.[14]

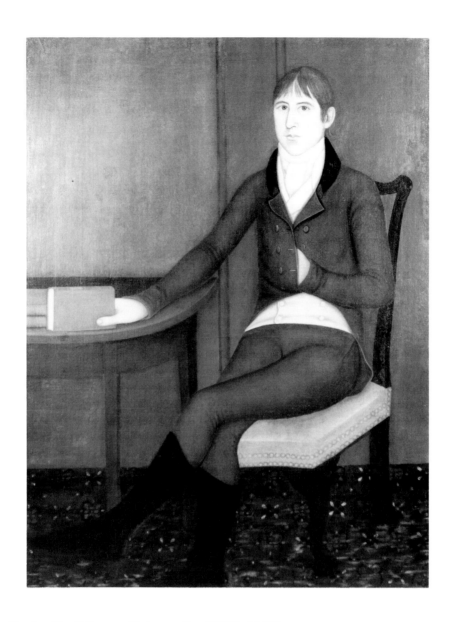

39 *Portrait of James Prince, Jr. (1781–1802)*
John Brewster, Jr. (1766–1854), Newburyport, 1801
Oil on canvas, 52 1/2 x 40 inches

An upholstered over-the-rail Chippendale side chair with Marlborough legs and a C–shaped Hepplewhite card table (or section of a dining-room table) were selected by the artist, or perhaps the patron, as furniture props for the portrait of James Prince's namesake. Painted when he was twenty, James Prince, Jr., died almost a year later far from Newburyport in Puerto Bello, a port in Panama.

Reference:
Benes, pp. 96, 97.

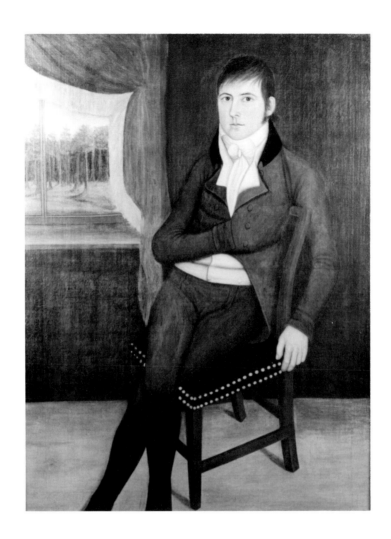

40 *Portrait of Benjamin Prince (1782–1815)*
John Brewster, Jr. (1766–1854), Newburyport, 1801
Oil on canvas, 52 x 40 inches

Benjamin, the second son of the merchant Prince, appears very relaxed in a
Chippendale side chair upholstered in black horsehair with contrasting brass
tacks. He is depicted in an uncarpeted room of the Prince house next to a green-
swagged drapery with long yellow fringe. The stand of pine trees visible through
the window has no connection to the Prince family's State Street garden.

Reference:
Benes, p. 97.

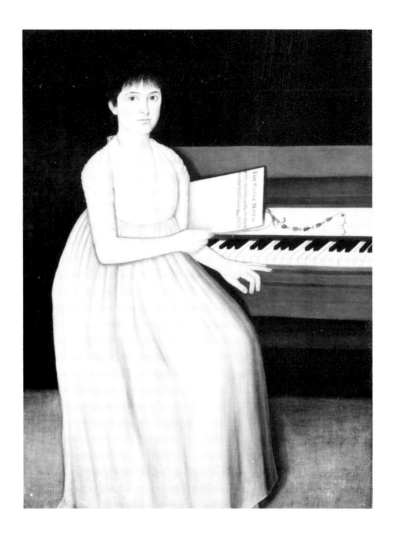

41 Portrait of Sarah Prince (1785–1867)
John Brewster, Jr. (1766–1854), Newburyport, 1801
Oil on canvas, 52 1/2 x 39 3/4 inches
Collection of Joan K. Davidson

The only daughter in the Prince household, Sarah is shown wearing a full, high-waisted white dress with delicate matching fichu. She is seated in a mysterious dark void next to a Hepplewhite piano with painted oval reserve and trailing bellflowers. The sheet music to "The Silver Moon" unfortunately hides the name of the piano's maker, but it adds juxtaposed interest to the charming portrait. Brewster's particular way of painting hands is very noticeable here. Sarah Prince Doane survived all the male members of her immediate family as well as the artist who painted her portrait.

Reference:
Benes, p. 97.

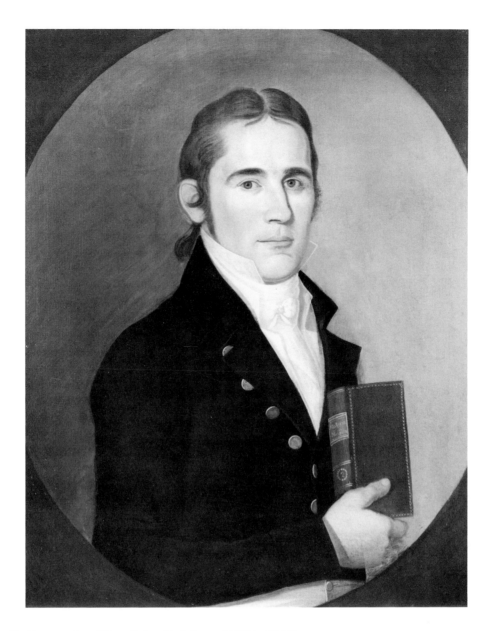

42 *Portrait of Dr. John Brickett (1774–1848)*
Attributed to William Jennys (active 1795–1810), Newburyport, ca. 1805–1807
Oil on canvas, 29 1/2 x 25 inches

Dr. Brickett, who was also an apothecary, is shown holding a leather-bound book, *MATERIA MEDICA, volume 2,* with its spine title visible. In the month of September, during the War of 1812, he served as surgeon on board the privateer *Decatur.* William Jennys often favored the artistic device of a dark spandrel to surround his bust-length portraits.

Reference:
Currier, Vol. II., p. 303.

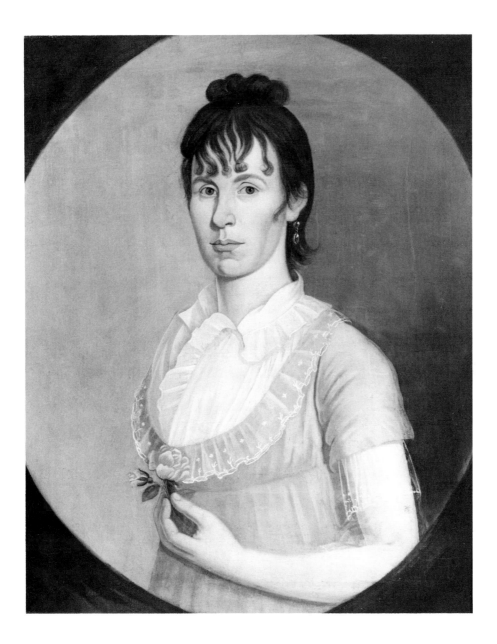

43 *Portrait of Elizabeth Ayer Brickett (1777–1807)*
Attributed to William Jennys (active 1795–1810), Newburyport, ca. 1805–1807
Oil on canvas, 29 1/2 x 25 inches

Mrs. Brickett is fashionably coiffured and attired in a high-waisted fawn-colored dress that almost recedes into the similarly colored background, used in both portraits. She was almost thirty when her likeness was fortunately captured for posterity, as she died in mid-March of 1807.

Reference:
Currier, Vol. II., p. 303.

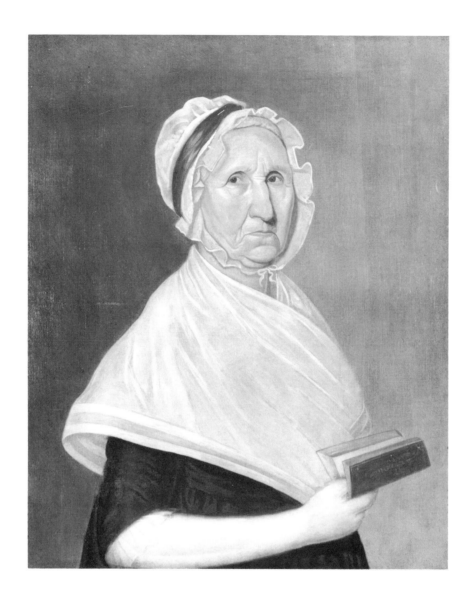

44 *Portrait of Mary Barlett Somerby (1731–1819)*
Attributed to William Jennys (active 1795–1810), Newburyport, ca. 1805–1807
Oil on canvas, 30 1/2 x 25 3/8 inches

The arch-eyed and tight-lipped mother of eight children has paused while reading
a book, a well-known prop used by portrait painters. Another visually strong
likeness is that of Capt. James Clarkson (1785–1867) which has an accompanying
bill signed and dated by the artist on April 30, 1807; Jennys also provided the
Newburyport maritime captain with a frame (OTW, p. 122).

Reference:
Benes, p. 94.

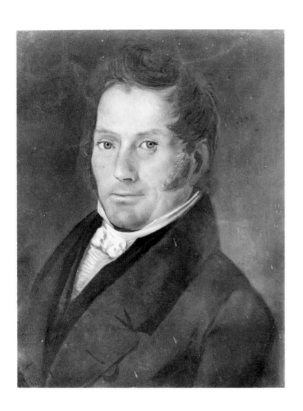

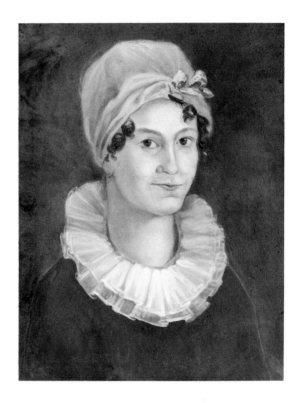

45 *Portrait of Thomas Perkins (1773–1853)*
Attributed to Moses Dupre Cole (1783–1849), Newburyport, 1818
Oil on laid paper, 19 1/2 x 15 1/4 inches
Society for the Preservation of New England Antiquities

Born in Topsfield, another Essex County town, Mr. Perkins moved to Newburyport where he succeeded Moses Davenport as innkeeper of the well-known hostelry, the Wolfe Tavern, for three years between 1804–1807.

46 *Portrait of Elizabeth Story Perkins (1778–1864)*
Attributed to Moses Dupre Cole (1783–1849), Newburyport, 1818
Oil on cardboard, 19 1/2 x 15 inches
Society for the Preservation of New England Antiquities

The daughter of Daniel and Ruth Burnham Story of Essex, Massachusetts, and Dunbarton, New Hampshire, Elizabeth Story married Thomas Perkins in 1804 and assisted him while he managed the tavern.

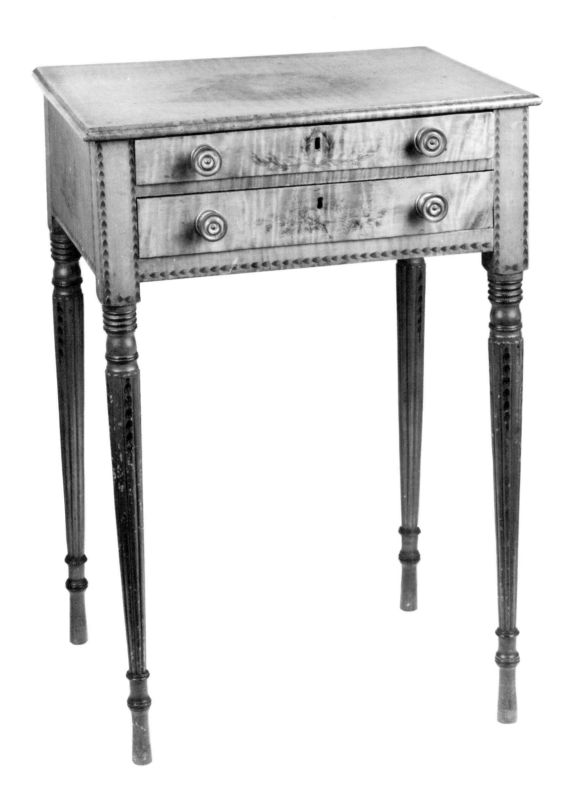

64

Fancy-painted Furniture

The enrichment of early utilitarian objects with a coat of plain milk paint or with oil paints in a spirited, freehand manner, sometimes with the use of stencils, is a much admired decorative aspect of American folk art. Practitioners of decorating with paint brushes and graining tools were mostly anonymous, although some inscribed their names in paint, chalk, or graphite somewhere on the objects they enhanced. These decorative artists received inspiration in the eighteenth and nineteenth centuries from available British and American publications; the creative craftspeople perfected their own styles and experimented with different colors and textures to delight their patrons and themselves.

Many cabinetmaking and fancy-painted furniture shops were located in the downtown area on Middle Street, along with several millinery shops and the office of the *Newburyport Herald.* On that street were the shops of Daniel Abbot, Elijah Bliss, E. Dole, S. Dole, Clark Morss, G. Parker, and Southy Parker. The Newburyport Chair Factory was situated for a time in the Market House in Market Square, and the furniture company of Abner and Edward Toppan, in partnership with Porter Russell, "did a large business in the manufacture and sale of furniture. Mr. Abner Toppan has a two story shop contiguous to his house on High Street."[15]

47 Work Table (opposite page)
Cabinetmaker and artist unknown, probably Newburyport, ca. 1820
Maple and pine, 28 1/4 x 19 7/8 inches
Private collection

Related to a select group of North Shore work tables, this recently discovered example shares many similarities with Federal-period work tables made in Newburyport and Salem. Often painted with vermillion vignettes of Gothic structures and ruins, combining delicately drawn neoclassical musical trophies, fruit and flowers, seashells, and other motifs, most curly-maple work tables have oval or turret corners; this table has a square top with molded edges. Tables decorated by Mary Ann Poor (born 1806), who attended an academy in Newburyport (Peabody Essex Museum collection), by Nancy Pearson Huse (1806–1845) of Newbury, and by Nancy Harris, (both in private collections) have variations in their turned legs. The one illustrated has reeded legs with painted husks and the Poor table has distinctive brass-capped feet.

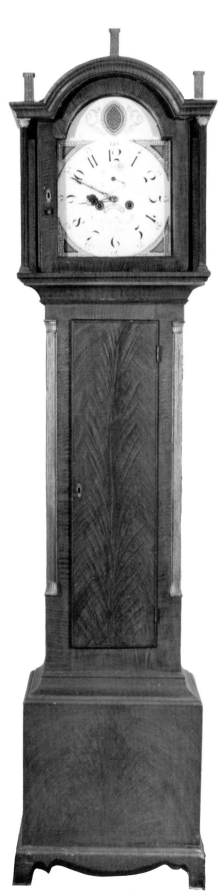

66

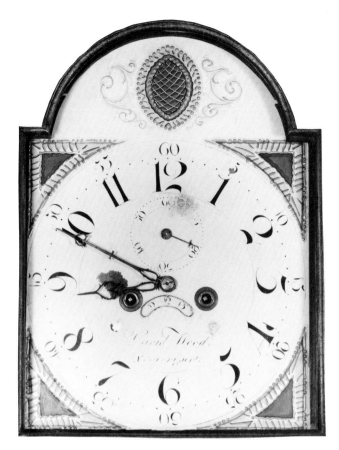

48 Tall Case Clock (opposite page)
Cabinetmaker and grainer unknown; movement by David Wood (1766–after 1824), Newburyport, 1810–1820
Grained pine, 85 1/2 x 19 3/4

Muted brown feather graining in imitation of mahogany veneer expertly conceals the pine case of this tall case clock, perhaps the only painted one of its kind with a movement by the most prolific clockmaker of the Federal period. "Mr. David Wood made clocks, in a shop which was one of the front rooms of his dwelling house on State Street. It was common to convert the front room of a house into a shop A door led from the shop into the living rooms of the the family Mr. Wood's clocks were the tall, mahogany-cased time-keepers then fashionable. The dial, in addition to the usual face, was furnished with a second hand; some told the day of the month, the maker's name being inserted in the centre, below a bouquet of roses. These clocks were in great demand, scarcely a house was without them in all the region about."

References:
Benes, p. 80.
Emery, p. 232.

48a Clock Face (above)

48b Detail of painted decoration (opposite page)

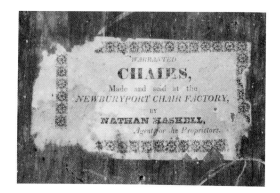

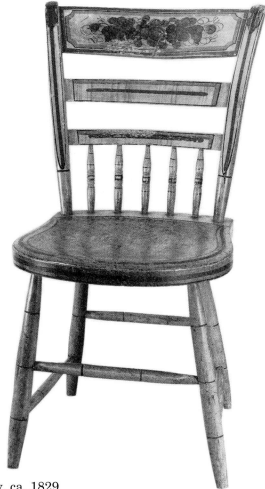

49 Side Chair
Maker unknown, Newburyport Chair Factory, ca. 1829
Painted pine and other woods, 33 1/4 x 18 1/4 inches
Society for the Preservation of New England Antiquities

An indented panel with hand-painted powdered-bronze fruit and curvaceous tendrils is the main decoration on this straightforward yellow Windsor side chair with modified bamboo-turned legs. Nathan Haskell (born 1805), agent for the factory's proprietors, ran an advertisement in the *Newburyport Herald* from April 13 to May 26, 1829 in which he informed the public that he stocked "Chairs, of every description . . . worth from $2.50 to $4 each – Fancy Chairs, Windsor Chairs, and Box Chairs for Shipping. Any pattern or color, made to order. WASH–STANDS, CHAMBER–TABLES, Bureaus, and Work stands, of every description, always on hand, at wholesale or retail"

Reference:
Nina Fletcher Little, *Little By Little* (New York: E. P. Dutton, Inc.), 1984, pp. 209, 210.

49a Label Under Chair Seat (above)

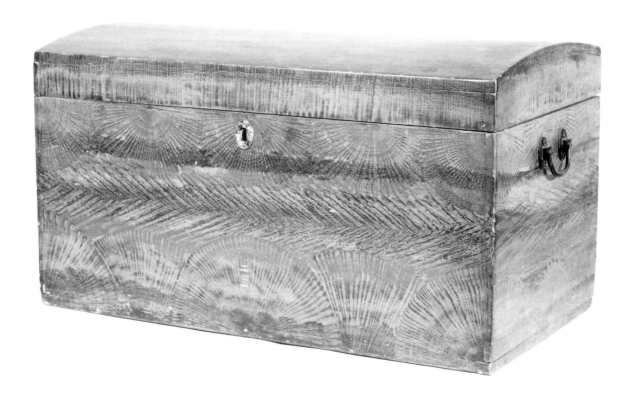

52 *Trunk*
Maker and grainer unknown, Newburyport, ca. 1836
Polychromed pine, 14 x 26 inches

Firm leather strips may have been used by the very competent grainer to make the fan and herringbone patterns on this slightly domed trunk. It is lined with pages from the *Newburyport Herald,* November 25, 1836, and features an advertisement placed by Stephen D. Shaw for his furniture and crockery warehouse, located at No. 4 East Row in Market Square. The accompanying large cut depicts a high-styled upholstered Grecian couch, and the ad mentions "GRECIAN WASH STANDS AND DRESSING TABLES; PAINTED [ditto]"

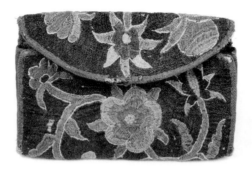

53 Crewelwork Pocketbook (above)
Maker unknown, Newburyport, mid-18th century
Polychrome wool on linen, 4 1/4 x 7 inches

Oversize, brightly colored wool flowers on a dark-green background, bearing a
strong resemblance to those in early tree-of-life textiles, cover this two-section
pocketbook with flap. It was inherited, along with generations of heirlooms, by
the five Misses Emery of West Newbury.

54 Bedstead Valance Section (below)
Maker unknown, probably Newburyport, mid-18th century
Polychrome wool, 5 1/4 x 100 inches

Trailing vines with vibrant exotic flowers fill the two long sections of this
unfinished partial valance set.

Household Effects

Miscellaneous handmade objects made for use in the home document different aspects of daily life of the past and are referred to today as material culture by decorative arts scholars. Whether made from imported materials or made locally, the artifacts we admire speak to us about form and function, color, a simplicity of design, and durability of construction.

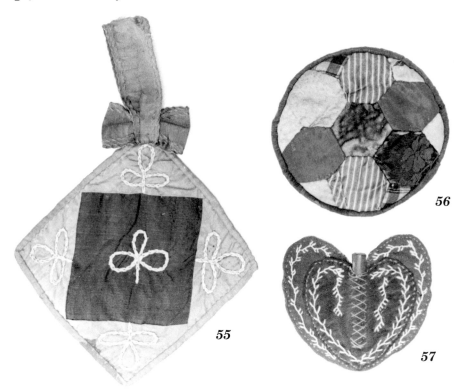

55, 56, 57 Sewing Accessories
Blaisdel–Boltenhouse–Atkinson family members, Newbury, 19th century

(55) Hand-stitched potholder made from silk with embroidered silk shamrocks, 5 1/2 inches square; (56) hand-stitched quilted pincushion made of silk with velvet and faille on homespun linen, 4 x 3 1/2 inches; (57) hand-stitched heart-shaped needle holder made of wool, faille, and leather with cotton threads in a conforming vine pattern, 3 x 3 1/2 inches.

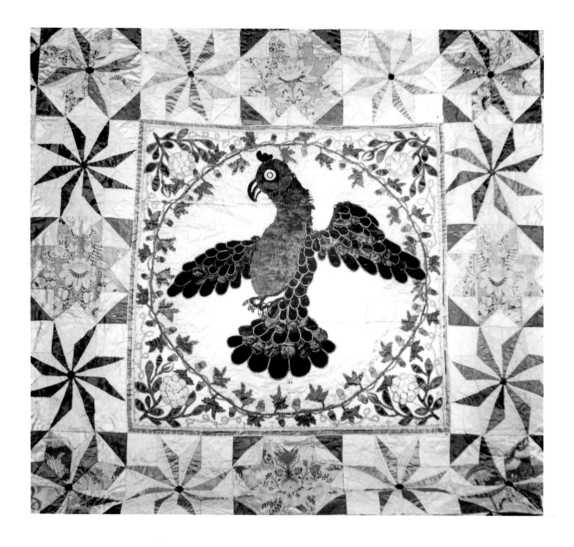

58 Pieced, Appliquéd, and Embroidered Quilt (Detail)
Attributed to Phoebe Harrod (1786–1887), Newburyport, ca. 1825–1845
Polychrome silk, velvet, and cotton, 102 inches square
(Illustrated in color on the back cover)

A patriotic eagle is the finely feathered feature in the center of this visually
appealing quilt with cut foot post corners, associated with the milliner Phoebe
Harrod and female members of her family. The body of our national emblem is
made of brown chenille and the velvet wing and tail feathers resemble the colorful
overlapping sections of Victorian penny rugs. Pieces of plain, stripped, patterned,
and floral Continental and Chinese brocade and damask silks in various star patterns
were probably made from the remnants of expensive eighteenth century clothing.

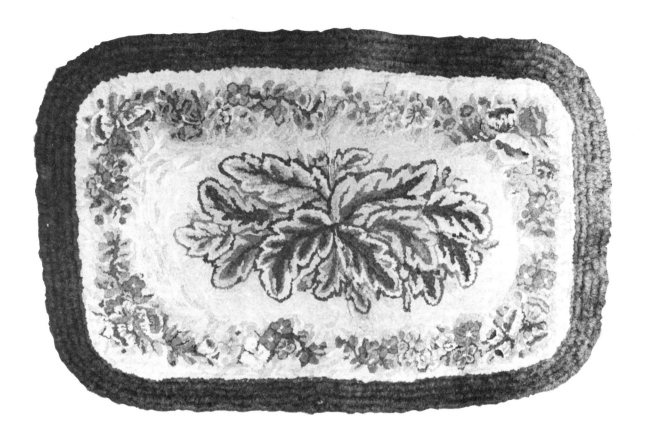

59 Hearth Rug
Sarah Ellen Smith (1852–1931), West Newbury, late 19th century
Wool and other materials, 35 x 23 1/2 inches
Historical Society of West Newbury

A glimpse between the faded flower petals of this documented rug reveals the bright colors used by the daughter of Amos and Sarah Dole Smith (28) to create one of the many floor coverings she made and sold during her lifetime. Resembling a hooked rug, this "caterpillar" shirred example was made by running thread through the puckered strips of fabric and sewing it to the backing.

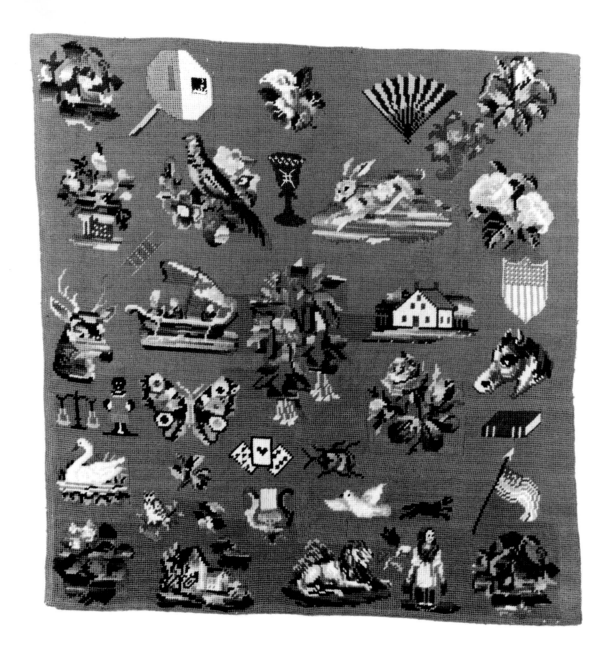

60 *Needlepoint Pictograph*
Maker unknown, probably Newburyport, ca. 1876
Wool on canvas, 21 1/4 x 20 3/4 inches

A bright red background serves as the unifying color of this thoughtfully designed
gros point vocabulary of motifs picture. The American flag and shield, a Japanese
hand-fan at the top, and the use of chemically manufactured aniline dyes seen
throughout indicate the late nineteenth century origin of the piece, which was
probably worked for the centennial celebration.

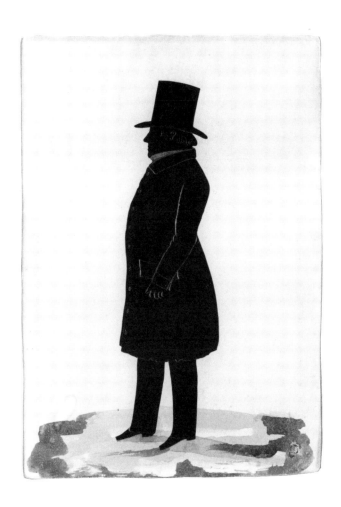

61 Silhouette of Richard Pickett (1788–1847)
Philip Lord (born 1814), Newburyport, ca. 1845
Cut and pasted paper with graphite and ink wash, 10 7/8 x 8 1/2 inches

Several itinerant silhouette artists visited Newburyport during the first half of the nineteenth century, foremost among them being William King (active 1804–1809) and William Bache (1771–1845). The latter worked with the time-reducing aid of a physiognotrace, which projected and reduced the sitter's profile onto a surface for tracing. Between 1804 and 1809, King is purported to have cut silhouettes of well over eight thousand Salem and Newburyport residents. Master mariner Richard Pickett was admitted as a member of the Marine Society of Newburyport in 1819.

References:
Benes, p. 97.
Marine Society of Newburyport, *History of the Marine Society of Newburyport,* edited by William H. Bayley and Oliver O. Jones, (Newburyport: Press of the *Daily News*), 1906, pp. 144, 204.

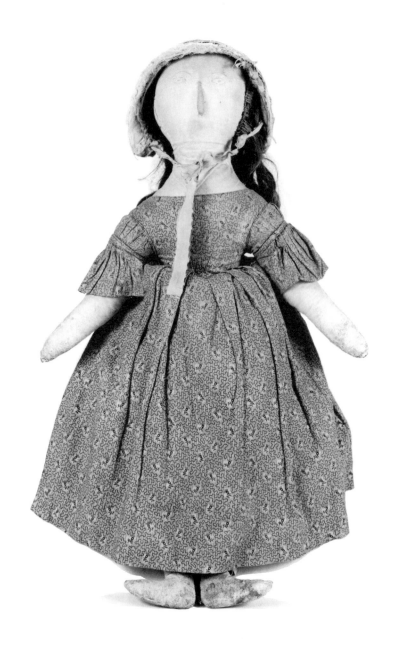

62 *Rag Doll*
Maker unknown, probably Newburyport, ca. 1825–1850
Linen, kidskin, cotton, 23 1/2 x 14 1/2 inches

Tall for her type, this nameless, standing Queen Anne-style rag doll has a linen head and shoulders with fingerless kidskin arms and shoeless feet. Her flat, simply drawn eyes and eyebrows are in contrast to her applied, inverted carrot-shaped nose. The doll's free-flowing brown hairpiece is sewn to her scalp, and she is wearing a fashionable beige silk chapeau. Her modified Empire-style light-brown, printed cotton dress has an overall jigsaw-like design with a red floral sprig motif, and she is wearing her original underwear!

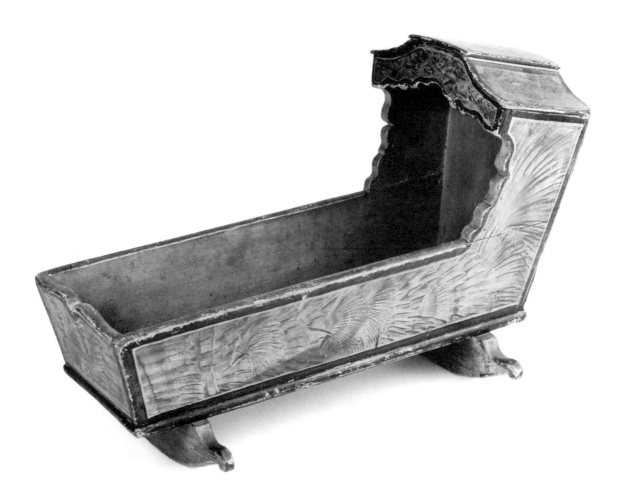

63 *Doll's Cradle*
Maker unknown, probably Newburyport, early nineteenth century
Polychromed pine, 10 x 15 1/4 inches

The talented person who grained the locally made, newspaper-lined trunk (52)
also may have decorated this chromatic cradle.

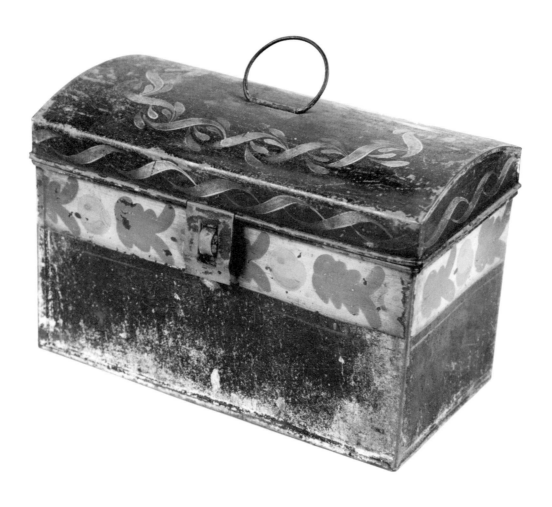

64 Document Box
Maker and decorator unknown, possibly Newburyport, ca. 1830–1840
Japanned tin (tôleware), 5 3/4 x 8 3/4 inches
Historical Society of West Newbury

Three sides of the domed lid of this document or trinket box have an interwoven yellow ribbon motif repeated as an oval on the top with flanking leaves of the same color. Alternating bright red apples and stylized green leaves appear on the contrasting white band. Although not documented to having been made in the area, the decoration is similar to that on another box of the same period known to have been painted locally. In November of 1830 interested ladies of Newburyport were able to view such functional "Specimens" at Mr. Ebenezer Stedman's bookstore, where they could inspect the work of Mary S. Brown and inquire about her "Lessons in the art of Japanning."

Reference:
Newburyport Herald advertisment, p. 32.

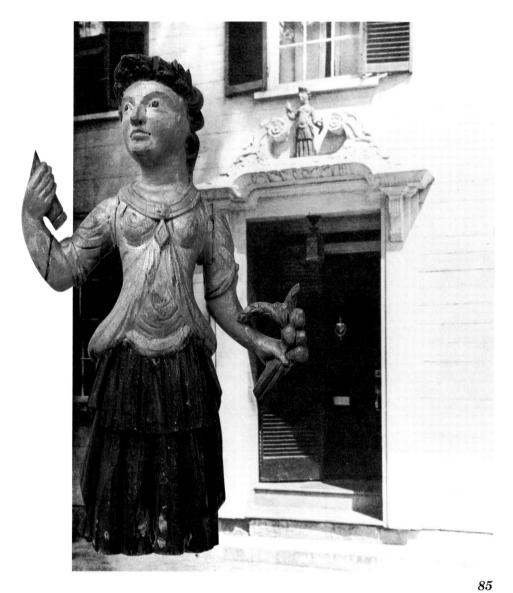

84 *Architectural Sculpture of a Goddess*
Attributed to Joseph Wilson (1779–1857), Newburyport, ca. 1800
Polychromed pine, 21 x 12 1/4 inches

For his 1941 photographic survey book of local architecture, John Mead Howells
borrowed this enchanting statue (thought to be Ceres, the Roman goddess of
agriculture) from HSON and had it photographed where he believed it was
originally located – in the center of the distinctive molded and carved broken
scroll pediment of the Paul Noyes house (85), built around 1769 at the corner
of Market and Washington Streets.

Reference:
Howells, p.113.

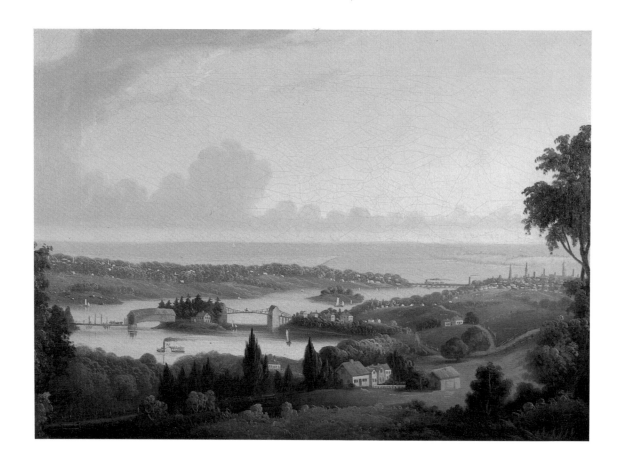

4 *View Near The Laurels, Newbury*
Attributed to Joshua Sheldon, Jr. (1809–1890), Newburyport, ca. 1847
Oil on canvas, 21 x 29 inches
Private collection

This romantic painting of The Laurels was undoubtedly the prototype for the
1847 Bufford and Company print of the same name. Many interesting details of
rural Newbury in the foreground contrast with early industrial Newburyport in
the right background. The famous Chain Bridge, built in 1792, and a covered
bridge serve as focal points in the middle distance, around which sailboats and a
steam-powered paddleboat ply the Merrimack River.

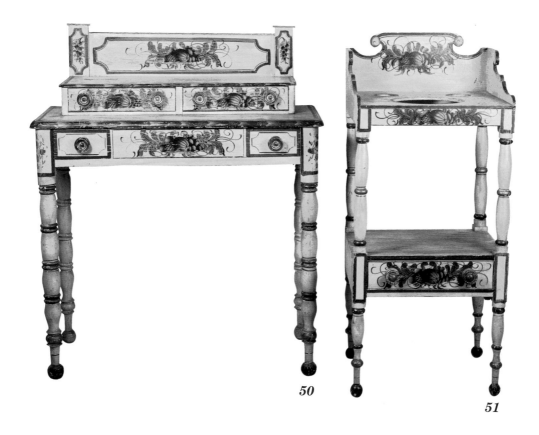

50

51

50, 51 *Dressing Table and Washstand*
Maker and painter unknown, Newburyport, ca. 1830
Painted pine, 40 1/2 x 34 inches; 39 3/4 x 17 3/4 inches

This fancy-painted dressing table and matching washstand were purchased from an unidentified cabinetmaker at one of the furniture shops in Market Square by Mr. and Mrs. Amos Smith to furnish their new home. In 1831 Sarah Dole (1810–1892) of West Newbury married Amos Woodman Smith (born 1800) of Crane Neck Hill; their son, Leonard Woodman Smith (1844–1933), the first curator of the Haverhill Historical Society, reminisced about the family home, stating among other things, that the back bedroom had a "canopy bed, mahogany furniture, Hitchcock chairs, and yellow decorative articles of furniture." These two pieces of bedroom furniture referred to by Mr. Smith were later presented by him to the Historical Society of Old Newbury. The yellow ochre ground color is enlivened by hand-painted and stenciled flowers and fruit with touches of metallic bronze powder.

Reference:
Leonard Woodman Smith, "The Greenleaf Place," *Haverhill Evening Gazette,*
 January 14, 1933.

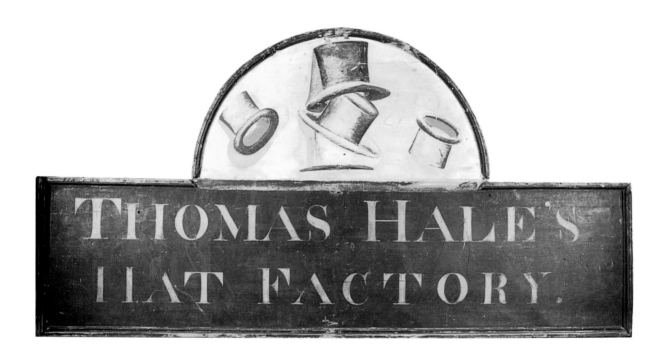

92 Hat Factory Trade Sign
Maker unknown, Newburyport, pre 1836
Painted pine, 42 1/2 x 84 inches

Topsy-turvy top hats adorn the arch of Thomas Hale's trade sign. Mr. Hale (1773-1836) operated the factory which was located in a building on his property at 348 High Street in the Belleville section of Newburyport. Four other hatters were in business at the same period on Water Street in the downtown area.

Reference:
Emery, p.273.

Maritime Pursuits

When the suffix "port" is added to the name of a seaside town or city, it denotes a special section with a definite maritime connection. The necessary maritime-related trades sprang up in Newburyport to support the mercantile interests of seafaring men (70), many of whom had already built wharves for their vessels along the northeast shore of the Merrimack River. Local coastal fishing, far-flung trade, and lucrative privateering ventures provided them with good sources of revenue during and after the Revolutionary War. The construction of made-to-order vessels for the British market was a thriving business during the first three-quarters of the eighteenth century, while the distilling of rum in several factories along the waterfront took precedence in the early nineteenth century.

To personalize their vessels with figureheads of themselves, their family members, or grander representations, and to decorate sternboards (71), local sculptors or carvers such as John Brett (ca. 1720–1792), Joseph Wilson (1799–1857), and other now-forgotten men were hired for their special three-dimensional talent. The heyday for such maritime-related decoration was during the first half of the nineteenth century before the advent of steam made sailing ships obsolete for commerce, much as the daguerreotype curtailed portraiture around the same time.

Scrimshaw carving (65), woodcarving, and the crafting of personalized objects (72) were favorite pastimes of becalmed creative seamen on long voyages. Some men without sea legs carved decoys (76-79) for hunters of salt and fresh-water fowl. The addition of paint embellished most of these surfaces, and the patina of the years has enhanced their charm even more.

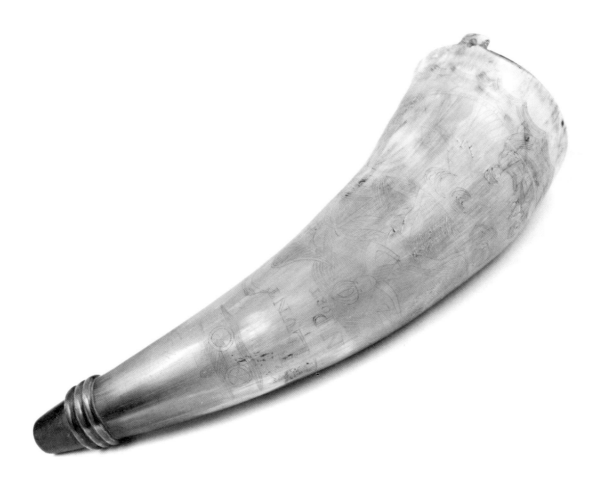

65 Powder Horn
Thomas Lunt (born 1748), Newbury, late 18th century
Carved horn and wood, 8 1/2 x 2 1/4 inches
Private collection

The scrimshander delicately encircled the inscription "T LUNT/N PORT" with (clockwise): a hand-tub—the name for a late eighteenth–early nineteenth century fire apparatus; an American eagle emblazoned with a shield; a duel in which a combatant has been stabbed by another wearing an acorn-shaped helmet; and a trophy arrangement of crossed horns, sword, drum, and pile of cannonballs. An in-the-round vignette near the wood insert depicts six men in a longboat three of whom are brandishing weapons at four men who are returning fire on a small island with palm trees. A two-masted vessel is on the other side of the island, and a cannon on wheels near the crossed flags is visible under the longboat.

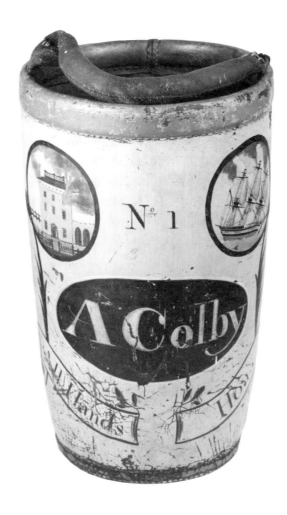

66 *Fire Bucket*
Maker and artist unknown, Newburyport, ca. 1810–1825
Leather and paint, 13 3/4 x 8 3/4 inches
Private collection

Graphic portrayals of a brick Federal-period mansion being engulfed by flames and smoke and a foundering three-masted vessel flank leather fire bucket No.1 owned by Abraham Colby. A similar design with the popular motto "All Hands/Hoa" appears on an apple-green "MARINE" fire bucket originally owned by Micajah Lunt in 1776 (private collection). The account book of the Marine Society of Newburyport (founded in 1772 and dissolved in 1911) states in its second article: "That each of us will always keep in good Order, hanging up in some convenient place in our Respective dwellings, Two Leather Buckets in which shall be Two Bags, Each bag measuring one yard and half in Length, and three quarters of a yard in Breadth, being hemmed at the mouths and having Strong string to draw the close, the Bucketts and bags shall be Marked with the first Letter of the Owners Christian name, and with his surname at length, under penalty of three shillings for Each Deficiency."

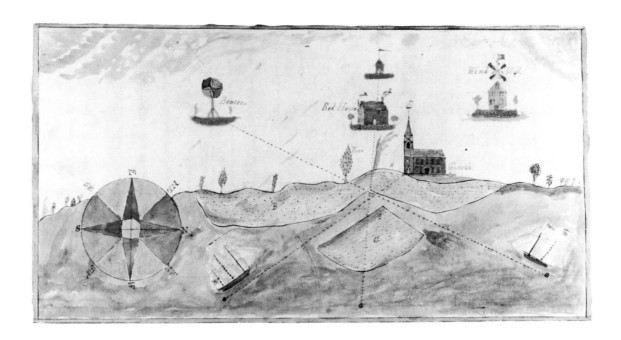

67 *Navigational Watercolor*
William Hale (1796–1857), Newburyport, ca. 1810
Watercolor and ink on paper, 6 x 11 3/4 inches
Private collection

"To take the shoals of a river's mouth and plot the same," navigational student
William Hale wrote in perfect penmanship, one must "Measure first the sea-coast
on both side of the river's mouth and make a fair draught write down every
remarkable thing in it's true situation, as trees, house, town, wind-mills, etc.,
then going out in a boat to such sands or rocks as make the bearing thereof to two
known marks upon the shore; and having thus surveyed round all the sands and
rocks; you may easily draw lines which shall intersect each other at every
conceivable point of the sands, whereby you may truly point out the sands and
give directions either for laying buoys, or making marks upon the shore for the
direction of shipping."

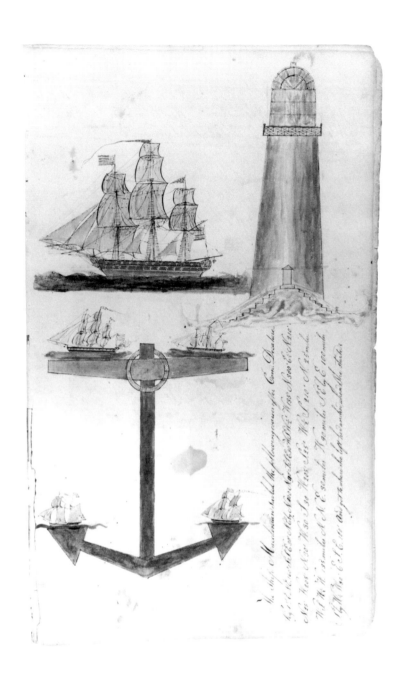

68 Navigational Drawings
William Hale (1796–1857), Newburyport, ca. 1810
Watercolor and ink on paper, 13 x 15 3/4 inches
Private collection

An eye for composition and color is evident in the combination of computation exercises and brief history of the *Macedonian* on this page of William Hale's copybook.

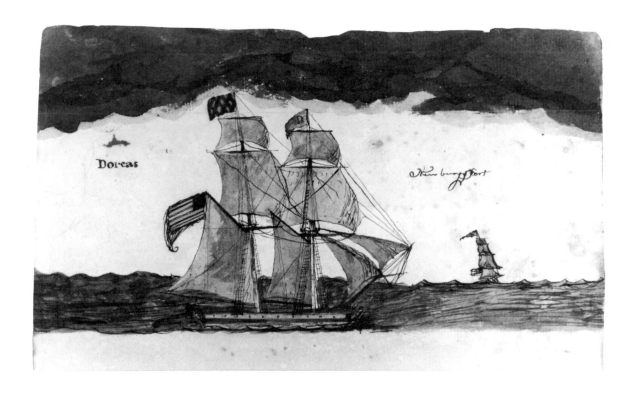

69 The Dorcas, *Newburyport*
William Shaw (1796–1849), Newburyport, 1807
Watercolor and ink on paper in leather-bound ledger, 8 x 5/14 inches
Private collection

This small watercolor portrait of the *Dorcas,* evidently done at sea, was inscribed "The Property/of/William Shaw/Newbury Port/August 4th 1807."

Reference:
Newburyport Vital Records, Vol. II, p. 784.

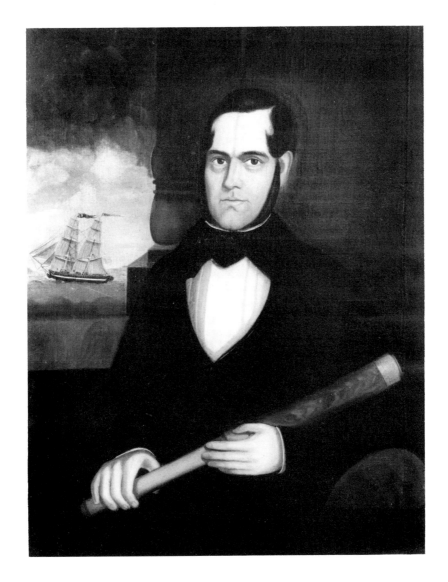

70 Capt. Charles Watts (1812–1875)
Artist unidentified, probably Newburyport, ca. 1850
Oil on canvas, 35 1/4 x 28 1/4 inches
Custom House Maritime Museum, Newburyport

The base of a classical column adds solidity, and serves as a backdrop to the portrait of Capt. Watts, who sports a gold earring. He is seated on an Empire sofa and holds what appears to be a grained telescope in his hands. Capt. Watts was involved in trade with the West Indies; the bounding brig in the background was christened the *Caroline,* the name of his wife.

Reference:
Robert K. Cheney, *Maritime History of the Merrimac* (Newburyport: Newburyport Press), 1964, p. 252.

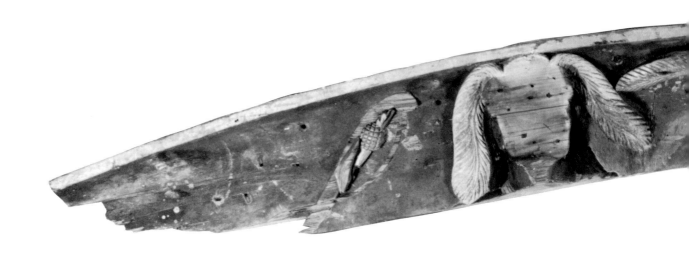

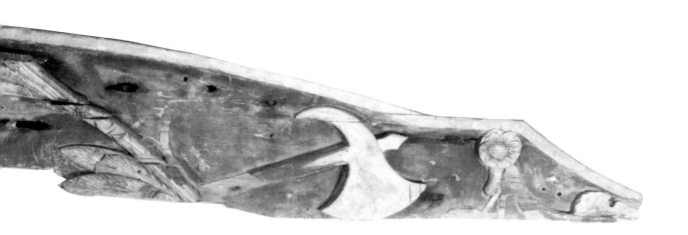

71 *Sternboard of the* Pocahontas
Maker unknown, Newburyport, 1830
Painted pine, 11 1/2 x 107 inches

This carved and painted sternboard is the only decoration saved from the 271 ton
brig *Pocahontas,* owned by Capt. John N. Cushing (1780–1849) of Newburyport,
which sank sometime before the morning of December 23, 1839, off Plum Island
in "the most destructive gale" recorded to hit the coast up to that time. Capt.
James G. Cook and chief mate Albert Cook, both local residents, and at least nine
crew members were lost "in the tremendous sea running" within sight of the hotel
on the island.

Reference:
Bayley and Jones, pp. 490, 491.

71a *Woodcarving of Neptune (opposite page)*
Maker unknown, probably Newburyport, late 19th century
Gilded pine, 10 x 11 3/4 inches
Custom House Maritime Museum, Newburyport

Flowing lines accentuate the bas-relief woodcarving of the Roman god of the sea
(missing part of his trident), probably used as interior decoration on a local vessel
or maritime-related business.

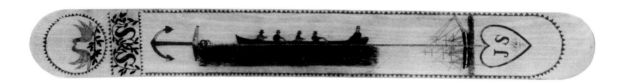

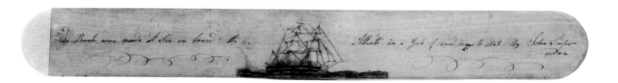

72 Busk
Capt. John Simpson (1802–1887), Newburyport, 1848
Holly or boxwood, 14 1/4 x 1 3/4 inches
HSON on loan to the Custom House Maritime Museum, Newburyport

Carved, inlaid, and hand-painted motifs on this bodice stay for a corset include
five men in a longboat with a large anchor and a sailing vessel, two love birds on
a branch above the maker's wife's initials "S S", and his own initials "J S" in a
heart with the date "1848." The reverse has a fully masted vessel in the center
with the longhand legend "This Busk was made at Sea on board the . . . *Allioth*–in
a Gale of wind May 7th 1842 by John Simpson."

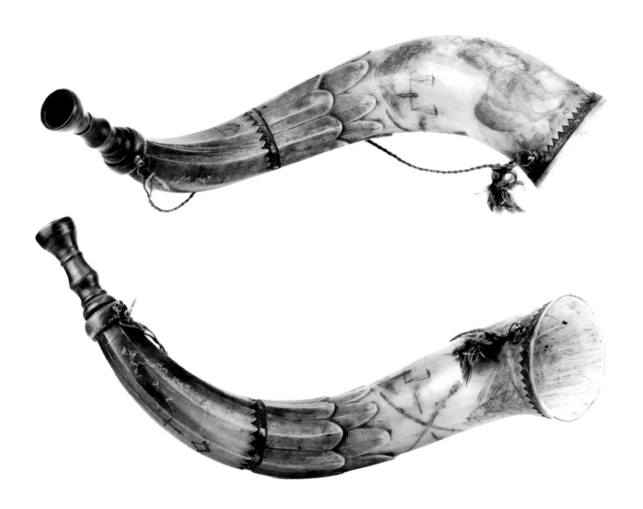

73 Foghorn
Capt. John Simpson (1802–1887), Newburyport, 1844
Horn and maple, 3 1/2 x 19 inches
HSON on loan to the Custom House Maritime Museum, Newburyport

Combining form and function, this impressive foghorn has a turned maple
mouthpiece and stylized feathers carved in high relief along with low-relief
scrimshaw carvings of an American eagle, a military officer on horseback, crossed
rifles, a sailing ship, and the well-known heart-in-hand motif. The circular
emblem of "Quascacunquen Lodge No. 30 I.O.O.F.–NEWBURYPORT/INST.
MAR. 4. 1844." is included among other decorations. Capt. Simpson joined the
Marine Society of Newburyport in 1843 and was the superintendent of their
rooms from 1868 to 1877. During his career he commanded the ships *Moses
Wheeler, Saladin, Alkmar, Gen. Harrison,* and *Astrea,* as well as the barks *Allioth*
(72) and *Statira.*

Reference:
Bayley and Jones, p. 387.

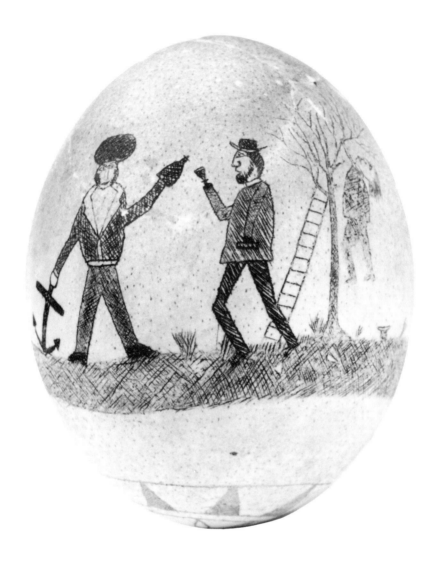

74 Ostrich Egg
Origin and scrimshander unknown, mid-19th century
Petrified egg, 6 1/4 x 5 inches
Custom House Maritime Museum, Newburyport

An unidentified maritime-related hanging scene was incised on this egg, shown in a display case with other artifacts in a ca. 1906 photograph taken in the museum room of the Maritime Society of Newburyport. A white marble tablet identifying the Marine Society and the date of its founding (1772) remains in the brick facade of the late Federal period building on lower State Street opposite Middle Street.

Reference:
Bayley and Jones, p. 129.

94

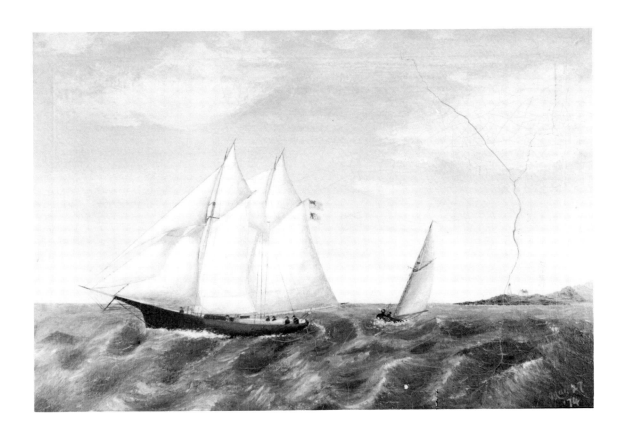

75 *Portrait of Yacht Lottie C.*
John Charles March Bayley (1850–1907), dated May 27, 1874
Oil on canvas, 11 1/4 x 17 1/4 inches
Custom House Maritime Museum, Newburyport

The son of Capt. Charles March Bayley (1814–1879), John C. M. Bayley was admitted to the Essex Bar Association and began to practice law in Newburyport five years after he completed this painting. The *Lottie C.* is shown at full sail off Plum Island at the mouth of the Merrimack River.

Reference:
Currier, Vol. II, p. 287.

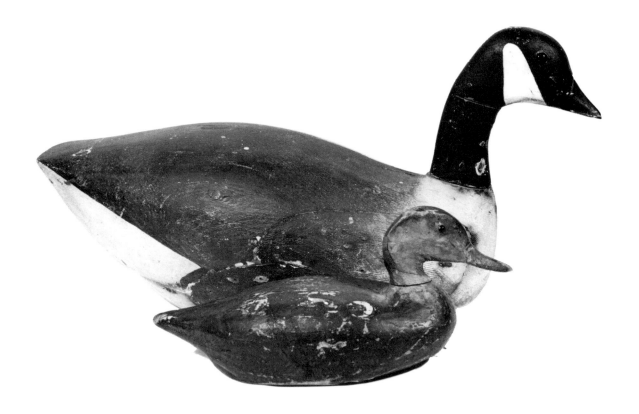

76 *Canada Goose Decoy*
Charles A. Safford, Newbury, ca. 1935
Carved and painted pine, 13 3/4 x 30 inches
Private collection

The carver of this decoy was a caretaker for the Annie H. Brown Wildlife
Sanctuary, prior to its becoming the Federal Wildlife Refuge on Plum Island. Mr.
Safford carved decoys during the time he lived at Hale's Cove on the island.

77 *Black Duck Decoy*
George L. Whitemore, Newburyport, early 20th century
Carved and painted pine, 7 x 17 inches
Private collection

A Newburyport mail carrier, Mr. Whitemore was an avid hunter and sportsman
who carved decoys for his friends and his own use. Species he enjoyed making
included black ducks, teal, and shorebirds, all with fine form and appeal.

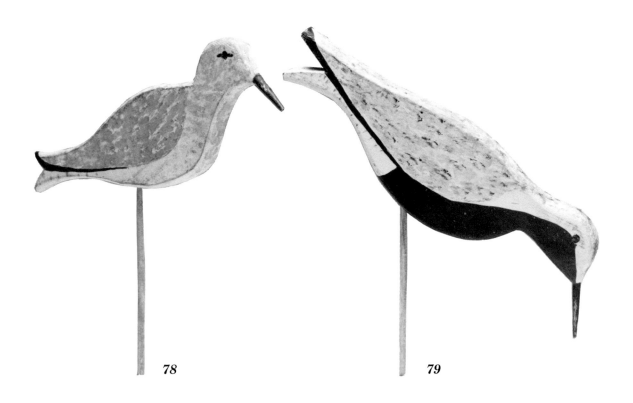

78, 79 *Pair of Plover Decoys*
H. Greenleaf Noyes (1897–1980), Newburyport, mid–20 century
Carved and painted pine, 11 x 11 inches; 11 1/2 x 11 inches
Peabody Essex Museum, Salem, Massachusetts

Referred to as "flatties," these black-bellied plover decoys represent a young adult
in non-breeding plumage in a standing or running pose (78), and an adult in breeding
plumage in a feeding pose (79). Black-bellied plovers and other shorebirds were
eagerly hunted for their marketability as food and for sport until 1932. The carver
of these decoys was one of the most famous sportsmen to reside in Newburyport,
where he lived in the South End. Mr. Noyes was an excellent bird and decoy
carver, and he was one of the first serious collectors in this area.

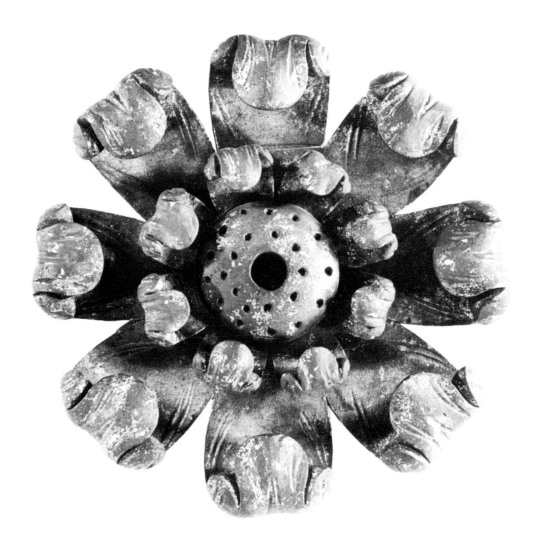

80 Architectural Rosette
Woodcarver unknown, Newbury, 1756
Carved, painted, and gilded pine, 15 1/2 inches diameter

William Davenport (1715–1773) of Boston carved figureheads for ships in
Newbury for almost twenty years during the mid-eighteenth century. He is a
likely candidate for the decorative woodcarvings that embellished the 1756 "Old
South" meeting house, then the largest wood-framed religious structure built in
New England. This eight-petaled blossoming rosette with a hole in the center
probably saw service as a pulpit canopy finial.

Reference:
Benes, p. 149.

Carved Icons

In the category of folk sculpture three coastal New England woodcarvers stand out for the quality of their work—Samuel McIntire (1757–1811) of Salem, Massachusetts, and John Haley Bellamy (1836–1914) of Kittery Point, Maine, produced distinctive sculpture for their wealthy patrons. In Newburyport, Joseph Wilson (1779–1857), a carver of ship's figureheads, achieved recognition for the statues he made for the mansion of self-styled "Lord" Timothy Dexter (1747–1806).

A native of Malden, Massachusetts, Dexter (81) possessed a worldly interest in the historical personages of the past (both European and American), and he had an expansive entrepreneurial instinct to be a showman. The wealth the eccentric merchant acquired through bizarre mercantile transactions allowed him to commission Joseph Wilson, sometime between 1799 and 1801, to sculpt forty-five larger than lifesize ". . . figers, two leged and fore leged" (four lions) to grace respective columns in front of his neoclassical-style "museum."[16]

As a teenager, Sarah Smith Emery (1787–1879) of West Newbury "vividly remember[ed] the ride down High Street, and father reigning in his steed, that I might gaze at . . . Dexter's images. Only a beginning of the show had then been made, Washington [and] Adams . . . adorned the front entrance, and the Lion and the Lamb reclined on either side" (83). She noted in an 1805 section of her autobiography that ". . . Dexter had increased his images; his plan was in full glory; Sentinels mounted guard. Jefferson had joined [the other presidents]. . . . Beneath [them] was a bass-relief of the Goddess of Liberty." Later in the book the author summed up her thoughts on the house and grounds by writing that "These figures were remarkable specimens in wood carving. In his work Mr. Wilson displayed the power of a sculptor; it is a pity he never aspired to works of greater durability."[17]

During the mid-nineteenth century J. H. Bufford of Boston captured in panoramic print form (83) what must have been a stationary carnival-like experience for the local citizens and curious visitors who came to inspect the likenesses of those illustrious men and women (the Goddesses of Fame and Liberty), whom they may never have heard about, but whom Dexter so admired. Alas, the polychromed statues did not survive in situ for more than eight years. Some were sold at auction in 1807, a year after the death of "his excellency Timothy Dexter, Earl of Chester, and Knight of the two open-mouthed lions." Most were felled by the "Great September Gale of 1815"; others were pulled down by an unsympathetic owner; and the rest, with the exception of William Pitt (82) and two unidentified arms and a hand (HSON collection; 82a) succumbed to dry rot."[18]

Dexter's "preposterous museum was . . . a folk artist's vision, an illiterate but imaginative distortion of the neoclassical garden or promenade–a descent, as it were, from the formal sophistication of marble sculpture to the provincial naiveté of ship's-figurehead carving."[19]

Other notable Newburyport carved and painted objects include a smaller goddess (84) than those on the Dexter fence and large or small secular (80, 86) and nonsecular pieces.

"I am the first in the East,
the first in the West,
and the greatest Philosopher
in the Western World,
Affirmed by me.
Timothy Dexter."

Engraved from the Life

by James Akin Newburypot.

The most Noble
Lord Timothy Dexter.
What a piece of work is Man!

81 Broadside of Lord Timothy Dexter (1747–1806)
James Akin (1773–1846), Newburyport, 1805
Copperplate engraving on paper 7 1/4 x 6 inches
Peabody Essex Museum, Salem, Massachusetts

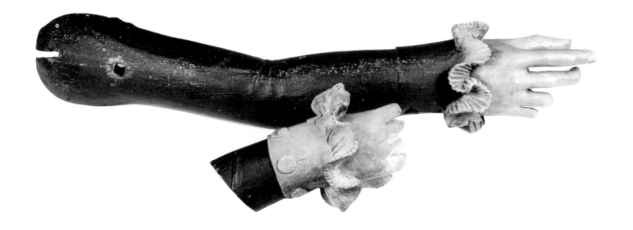

82 Architectural Sculpture of William Pitt (opposite page)
Joseph Wilson (1779–1857), Newburyport, ca. 1800
Polychromed pine, 78 x 23 inches
National Museum of American History, Smithsonian Institution

Occupying a pedestal at 201 High Street in Newburyport for only about eight years, this unique statue was acquired about 1880 by Boston antiquarian James L. Little. Based on the ca. 1840–1850 lithograph by J. H. Bufford, Mr. Little believed that the statue represented William Pitt "the Elder" (1708–1778). The auction at which the statue was sold included the figures of the first three presidents of the United States and the Goddess of Fame. Acquired by the Smithsonian Institution in 1949, the statue was restored and repainted in 1959. "The William Pitt statue is . . . set apart from other popular sculpture of its day. It is the product of an American folk artist and it is also a part of the larger expression of Timothy Dexter's ingenious, if eccentric, personality"

References:
Howells, p. 77.
Watkins, pp. 642, 643.
Benes, p. 109.

82a Carved Arm and Hand (above)
Polychromed pine, 37 1/4 x 7 inches; 12 x 7 1/2 inches

This arm and hand, with another matching arm (in the collection of HSON) and the Statue of William Pitt (82) are the only sculptural elements from Lord Timothy Dexter's fence in existence.

83 *"A View of the Mansion of the late LORD TIMOTHY DEXTER, in High Street Newbury port, 1810" (Detail)*
Artist unknown; after an aquatint attributed to John Reubens Smith (1775–1849);
John Henry Bufford (1810–1870), Boston, ca. 1840–1850
Lithograph, ink on paper, 12 1/2 x 24 3/4 inches

86 Steeple Finial
Attributed to Joseph Wilson (1779–1857), Newburyport, 1800
Carved, painted, and gilded pine, 34 1/2 x 18 inches
St. Paul's Church, Newburyport

Exposed to the elements for a hundred and twenty years, and almost consumed by fire in 1920, this unusual steeple finial was probably carved by the young Joseph Wilson. It was fashioned after the shape of a bishop's mitre and honors Edward Bass (1727–1803), the first Episcopal bishop in Massachusetts and the rector of St. Paul's Church. A carved and gilded replica beckons today's worshippers to the stone replica of the church.

87 St. Paul's Church (Detail)
Thomas Moore lithography firm, Boston (working 1836–1840). After an illustration by A. D. Gilman, 4 x 3 1/4 inches

Reference:
Benes, p. 179.

104

Trade Signs and Weathervanes

Visual landmarks for the retail and religious community that often served as prognosticators of weather, decorative trade signs and weathervanes added color to the facade of a building or steeple and defined its purpose.

Carved in relief, painted in polychrome colors, and often gilded (88), or flat with an attempt to portray perspective (92), trade signs helped the unlettered of the past to find their destination on shore. For those at sea, a tall church steeple (97) served as a beacon directing them to their "safe haven."

Nonsecular (100) and secular weathervanes, always appearing much larger in scale than when in situ, usually took the form of farm animals. In the town or city, angels, cockerels (98), fish (96), vessels (101), or the generic bannerettes predominated. In Newburyport, gilded angels, bannerettes, and cockerels have graced glistening, white, wooden church steeples from about 1770 to the present. Some reproductions have taken the place of originals in recent years.

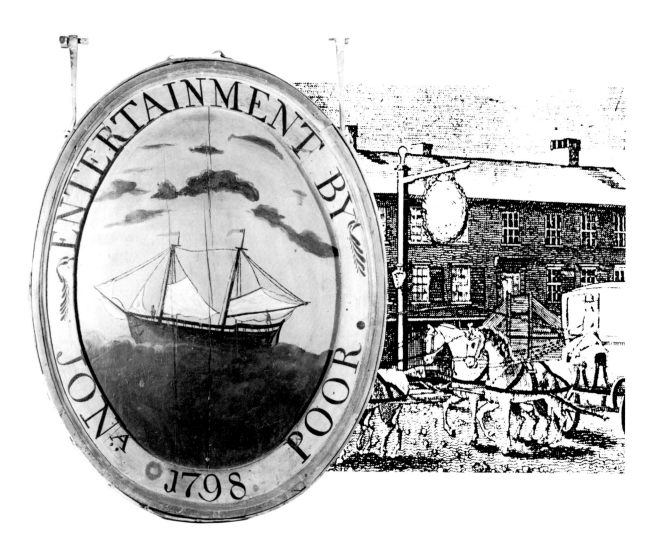

89 Tavern Trade Sign
Maker unknown, Newbury, 1798
Painted pine, 38 3/4 x 31 inches

An oval format was popular for tavern signs in the late eighteenth and early nineteenth centuries. This two-sided repainted sign has a pencil inscription "Established 1640" on the foresail of the two-masted schooner. Washington Adams donated the "Sign of second house of entertainment at Newbury, Old Town, kept by Jonathan Poor, in 1776, house built in 1664" to the Marine Society of Newburyport sometime after 1851.

Reference:
Bayley and Jones, p. 479.

90 The Wolfe Tavern (Detail)
Broadside, 1807

91 *Apothecary's Trade Sign*
Maker unknown, Newburyport, early 19th century
Gilded pine and wrought iron, 43 1/2 x 56 1/2

One of the most important trade signs of the times was that of the apothecary, who often was also a doctor (42). This large, three-dimensional hanging sign undoubtedly resembled that used by Dr. Lawrence Sprague of Dedham, Massachusetts, who began to practice medicine in Newburyport during the first decade of the nineteenth century. In 1812 Dr. Sprague "advertised drugs, medicine and spices for sale 'at his store on State Street, sign of the Pestle and Mortar' . . . and informed the inhabitants . . . that he still continued to practice his profession and was ready to attend patients needing the services of a surgeon or physician."

Reference:
Currier, Vol. II, pp. 300, 301.

94

93 Cigar-Store Indian
Maker unknown, probably Newburyport, ca. 1850–1870
Polychromed pine, 88 x 31 inches
Photograph courtesy of Hood Museum of Art, Dartmouth College, Hanover, New
Hampshire. Gift of the Class of 1930

This standing sachem was used as a trade sign by several tobacconists on lower
State Street during the mid to late nineteenth century. When William J. Creasey
operated his smoke shop at 6 State Street, and presumably acquired this trade
sign from a previous owner, he placed an advertisement in the city directory for
1878 which featured the printer's available cut of a muscular, seated Native
American (94).

Reference:
Newburyport City Directory, 1878, p. 272.

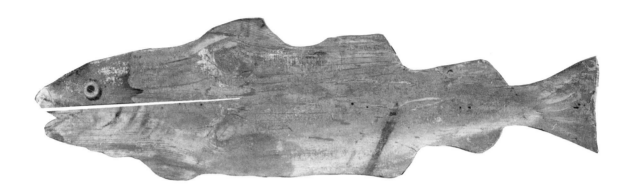

95 *Fish-Dealer's Trade Sign*
Maker unknown, Newburyport area, ca. 1900–1925
Painted pine, 18 x 57 inches
Private collection

This large, flat codfish, painted light blue, gray, and white, was attached to one side of Henry H. Woodard's wagon. In business in Newburyport and on Ring's Island, Salisbury, where he lived, Mr. Woodard (1895–1978) sold "ALL KINDS OF/FRESH FISH/IN THEIR SEASON . . . CAUGHT BY OUR/OWN BOATS."

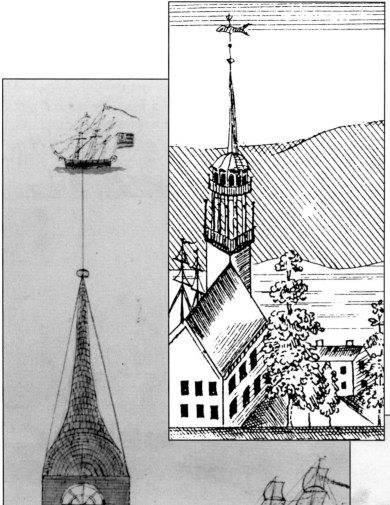

96
***North Congregational Society
1768 (Detail)***
Engraving by Benjamin Johnston

98
***"Old South" meeting house
(Detail)*** Lithograph,
ca. 1840

97
Meeting House (Detail)
Watercolor drawing by William Hale, ca. 1808

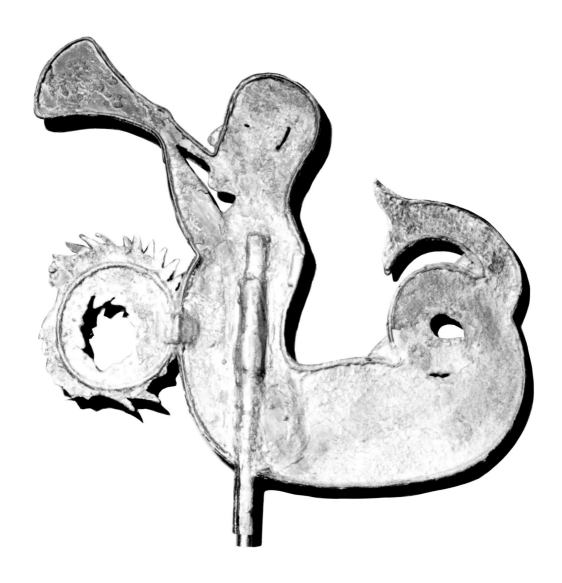

99 *Weathervane of Triton*
Maker unknown, Newburyport, 19th century
Gilded sheet metal, 15 1/2 x 15 1/2 inches

Beckoning seamen or mermaids instead of churchgoers, this weathervane of a
merman was probably on one of the many wharf counting houses along the
waterfront, where it surfaced during a dredging operation.

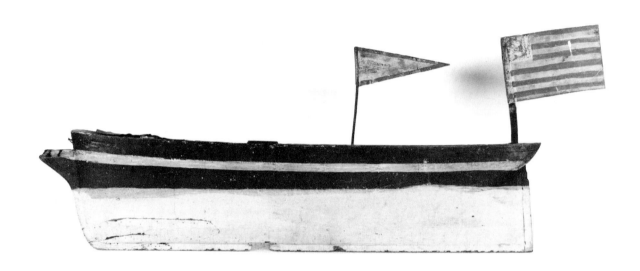

100 Weathervane of a Ship
David Hale Knight (1869–1892), Newburyport, ca. 1885
Polychromed pine and metal, 17 1/2 x 43 1/2 inches
Private collection

This weathervane represents one of the seven sailing vessels all beginning with
the letter *H*–*Halo, Hannah, Hazard,* and *Hiawatha* are four of the names recalled
by a direct descendant–owned by brothers David (1800–1877) and Isaac
(1803–1872) Hale, who were in business as grain merchants "D & I Hale" on
Hale's, and later on the city wharf, from the 1840s through the 1860s. The
weathervane was attached to a carriage shed in Newbury before it blew down in a
storm.

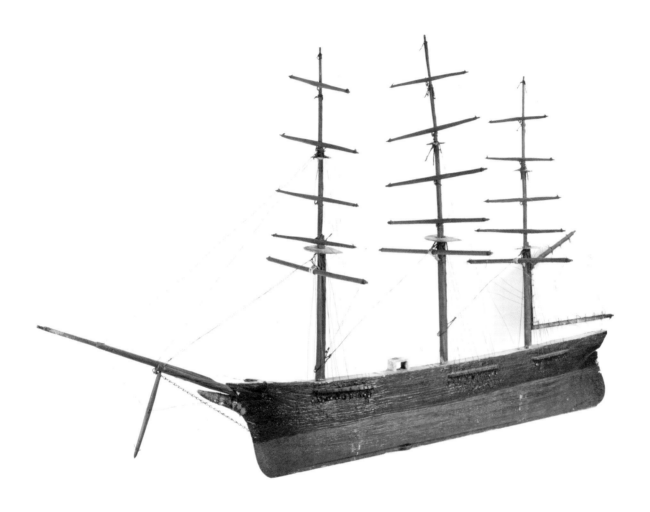

101 Weathervane of a Ship
Maker unknown, probably Newburyport, mid to late 19th century
Painted pine and wire, 36 x 52 1/2 inches

The largest shipyard on the Merrimack River belonged to John Currier, Jr. (died
1887). In operation from the 1830s to the 1880s, it was noted for the construction
of approximately 101 large vessels, one of which may have been the model for this
weathervane.

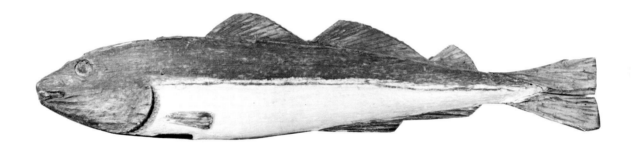

102 Weathervane of a Fish
Maker unknown, probably Newburyport, 19th century
Polychromed pine, 9 1/2 x 42 inches

A later coat, or more than one coat of paint, was added over the years to spruce up this sacred cod.

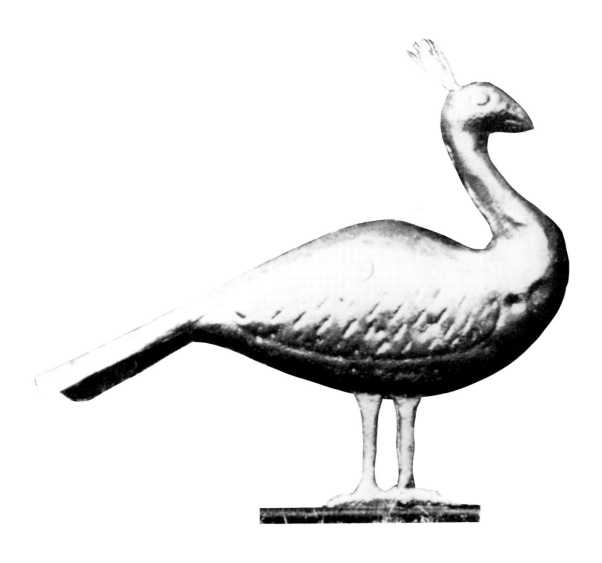

103 Weathervane of a Peacock
Maker unknown, probably Newburyport, ca. 1815
Gilded metal, about 50 x 70 inches
Whereabouts unknown

Illustrated as an unusual weathervane in *Architectural Heritage of the Merrimack,*
this proud peacock indicated wind direction atop the barn of the Thibault house
at 8 Summer Street in Newburyport (razed in 1934 during construction of the
highway), and it is used here as the final illustration in this pictorial survey of
folk art of old Newbury.

Reference:
Howells, p. 196.

115

INDEX OF ARTISTS AND ARTISANS REFERRED TO IN THE EXHIBITION CATALOGUE

FOOTNOTES

1 Lipman, Jean and Tom Armstrong, *American Folk Painters of Three Centuries* (New York: Hudson Hills Press, Inc.), 1980, p. 220.
2 Ibid.
3 Coffin, Joshua, *A Sketch of The History of Newbury, Newburyport, and West Newbury, From 1635 to 1845* (Boston: Published by Samuel G. Drake); 1845, p. vii.
4 Currier, John J., *The History of Newbury, Mass., 1635–1902* (Boston: Damrell & Upham), 1902, p. 274.
5 Benes, Peter, *Old-Town and the Waterside* (Newburyport: Historical Society of Old Newbury), 1986, p. 37.
6 Emery, Sarah Anna, *Reminiscenses of a Nonagenarian* (Newburyport: William H. Huse & Co.), 1879, p. 222.
7 Information from Glee F. Krueger, March, 1994.
8 Emery, p. 239.
9 Mahoney, William F, *Commemorating the Two Hundredth Anniversary of St. John's Lodge A. F. & A. M., 1766–1966* (Newburyport: Newburyport Press, Inc.), 1966, pp. 3, 7.
10 Emery, p. 320.
11 Benes, pp. 92, 93.
12 Ibid., p. 97; 13 Ibid., p. 98; 14 Ibid., p. 98.
15 Emery, pp. 231, 232.
16 C. Malcolm Watkins, "Lord Timothy Dexter and the Earl of Chatham," *The Magazine Antiques,* December, 1962, p. 643.
17 Emery, pp. 32, 77, 251, 252.
18 Benes, pp. 109, 110.
19 Watkins, p. 643.

BIBLIOGRAPHY

Benes, Peter, *Old–Town and the Waterside*, Newburyport: Historical Society of Old Newbury, 1986.

Cheney, Robert, K., *Maritime History of the Merrimac / Shipbuilding*. Newburyport: The Newburyport Press, 1964.

Coffin, Joshua, *A Sketch of the History of Newbury, Newburyport, and West Newbury,* Boston: Samuel G. Drake, 1845.

Currier, John J., *History of Newburyport, Massachusetts, 1764–1905,* Newburyport: Author 1906.

Currier, John J., *History of Newburyport Massachusetts,* 1764–1909, Vol. II, Newburyport: Author, 1909.

Emery, Sarah Anna, *Reminiscences of a Nonagenarian,* Newburyport: William H. Huse & Co., 1879.

Fales, Dean A. Jr., "Essex County Furniture—Documented Treasures from Local Collections, 1660–1860." *Essex Institute Historical Collections* (July 1965); 167–244.

Groce, George C., and Wallace, David H., *The New York Historical Society's Dictionary of Artists in America,* New Haven: Yale University Press, 1957.

Howells, John Mead, *The Architectural Heritage of the Merrimack*, New York: Architectural Book, 1941.

Krueger, Glee F., *A Gallery of American Samplers,* The Theodore H. Kapnek Collection, New York: E. P. Dutton and the Museum of American Folk Art, 1978.

Little, Nina Fletcher, *Little by Little, Six Decades of Collecting American Decorative Arts,* New York: E. P. Dutton, 1984.

Lipman, Jean and Tom Armstrong, *American Folk Painters of Three Centuries,* New York: Hudson Hills Press, Inc., 1980.

Lunt, Thomas S., *Lunt, A History of the Lunt Family in America,* Salem: Salem Press, 1913.

Mahoney, William F., *Two Hundred Years of Saint John's Lodge,* Newburyport: The Newburyport Press, Inc., 1966.

Mariner Society of Newburyport, *History of the Marine Society of Newburyport,* edited by William H. Bayley and Oliver O. Jones, Newburyport: Press of the Daily News, 1906.

Ring, Betty, *Girlhood Embroidery: American Samplers and Pictorial Needlework,* 1650–1850, 2 Vols. New York: Alfred A. Knopf, 1993.

Silvestro, Clement M. and Barbara Franco, *Masonic Symbols in American Decorative Arts,* Scottish Rite Masonic Museum and Library, Inc., 1976.

LENDERS TO THE EXHIBITION

Anonymous; Custom House Maritime Museum, Newburyport; Joan K. Davidson; New York State Historical Association, Cooperstown, New York; Newburyport Masonic Temple Association; Peabody Essex Museum, Salem, Massachusetts; Society for the Preservation of New England Antiquities, Boston, Massachusetts; St. Paul's Church, Newburyport; West Newbury Historical Society.

PHOTOGRAPH CREDITS

Photographs in the catalogue were taken by Bill Lane, with additional photography by Leslie Atkinson (55, 56, 57, 90); David Bohl (45, 46, 49); David Casey (99); Helga Studio (16); and Mark Sexton (78, 79, 84).

Officers and Directors of the Historical Society of Old Newbury

President:	Clifford Bonney
President Elect:	Vicki E. Dyer
Vice President:	Christopher L. Snow
Recording Secretary:	Ruth Yesair
Corresponding Secretary:	Karen Colby Breen
Treasurer:	Susan Christ
Board of Directors:	Ann Lagasse
	Gregory H. Laing
	Peter Eaton
	Michael Fosburg
	Dr. Mary C. Beaudry
	C. Bruce Brown
	Charles O. Griffin
	Sandra Lepore
	Mae C. Bradshaw
	Sally Chandler
	Deborah Boynton
	Mary Kuist
	Scott Nason
Director and Curator:	John Hardy Wright